Making a decision to have a child—it's momentous.

It is to decide forever to have your heart go walking around outside your body.

—Elizabeth Stone

expectations ❀ THIRTY WOMEN TALK ABOUT BECOMING A MOTHER

expectations ❋ THIRTY WOMEN TALK ABOUT BECOMING A MOTHER

TEXT BY LAURIE WAGNER ❋

❋ *PHOTOGRAPHS BY ANNE HAMERSKY*

CHRONICLE BOOKS
SAN FRANCISCO

Text copyright © 1998 by Laurie Wagner. Photographs © 1998 by Anne Hamersky. All rights reserved.
No part of this book may be reproduced in any form without written permission from the publisher.

Printed in Hong Kong.
ISBN 0-8118-1674-5
Library of Congress Cataloging-in-Publication Data available.

Book and cover design: Tolleson Design, sf, ca
Cover photograph: Anne Hamersky

Distributed in Canada by Raincoast Books
8680 Cambie Street
Vancouver, B.C. V6P 6M9

10 9 8 7 6 5 4 3 2 1

Chronicle Books
85 Second Street
San Francisco, CA 94105

Web Site: www.chronbooks.com

This book is dedicated to Hannah Grace Roth,
who dances with angels

contents

I would like to thank my wonderfully sensitive partner, Anne Hamersky, who cares about taking pictures and who was a delight to work with. Thanks also to Lizette Montgomery, who transcribed interviews and made meeting deadlines possible; to Maria Elena De Lisle, who takes beautiful care of my daughter, Ruby Grace, and makes getting into my studio a possibility every day. Many thanks to all the women I interviewed, who trusted me with their stories; to smarty-pants friends Dayna Macy, Jeff Greenwald, Brian Hill, Lisa Jones, Carolyn Miller, Barb Rosens and Robbie Eiseman, who believe in me; to Anne Brazeau Hausler for excellent feedback on all things literary; and to my editors at Chronicle Books, Annie Barrows and Karen Silver, who trust me and are a pleasure to work with. To Beth Verret, who turned me on to mothers in Louisiana; and to Dr. Nicole Schlechter and Peggy Newman McClellan, who did the same in Nashville. To my dear old pal Daniel Leanse, who doesn't have much in the frig, but who has a really comfortable couch. To Laurie and Jenny in L.A., who paved the mama-path. To my beautiful family, Dad, Wally, Carol, Wendy, and Amanda, and especially my mother, Suzanne, who is an amazing person full of love, passion, and rage and who digs deep to learn her lessons. Finally, to Mark Wagner, my full-of-tricks partner, who keeps a powerful flame burning in our lives, and whose idea this book was. I am indebted to your unending support. And to my daughter, Ruby Grace Fuller Wagner, the true inspiration for this book, my teacher, my angel, my *boony shaynah mana puki.*
I love you baby.

—*L. W.*

I extend my heartfelt thanks to Laurie Wagner for her rousing engagement and for making her book our book; to all the women and children whose lives I entered with camera in hand, for their honesty and willingness to be photographed and, often, for their friendship, wisdom, and hand-me-downs; to everyone at Spindler Photographic Services; to Annie Barrows and Karen Silver at Chronicle Books, for their extensive visual vocabulary; to Gretchen Calhoun, for telling me about this project; to Seth Dickerman, a real perfectionist; to Josef, my magnificent two-year-old son, who informed my understanding of the subject in the most direct way; to my friends who watched Joey or let me crash in their guest bed while I worked: Laura, Kristie, Valera, Barbara, Beth, David, Carol, Sarah, Amy, Stuart, Lisa, Simon, Tim, Kit; to my husband, Scott Nygaard, for walking the walk with me and for filling our home with music and rock-steady love; to my dad, Albert, for telling me to "do it like I mean it"; and to my dear mother, Eleanor, who is my link between heaven and this earth.

—A. H.

During my seventh month of pregnancy, my husband Mark suggested that I write my next book about motherhood. I rolled my eyes. *"That's the last thing I want to write about!"* I replied with a sneer. Of course *he* thought it would be a perfectly natural subject for me, what with my impending motherhood. Wouldn't I be curious about the world I was about to land in?

Well, sort of. It wasn't that I didn't want to write about motherhood, but it wasn't exactly a world I wanted to identify with, either.

Mentally, I'd always pushed mothers aside. Their lives seemed so routine, and so much about children, home, meals, car pools, and laundry. I'd see them in the market, lugging their kids around, and it was so easy to veer away from them, especially when they were looking ragged and mean because the kids were acting up. On the contrary, when things looked beautiful and in control, I'd sneak extra glances, fantasizing about my own future family.

In general, I wasn't especially interested in talking to that bunch. Of course I wanted to be a mother one day, but I would be so *different* from any other mother because *I WAS A BOOMING METEOR OF A WOMAN WITH A LIFE FOR GOD'S SAKE!* I had energy! Ideas! Plans! No child was going to crash-land my party. You wouldn't find me slaving over laundry or wiping sticky green stuff off refrigerator doors. I wasn't going to be like those other mothers who whined, *"Oh! I cannot get a single thing done all day!" "You wimp,"* I'd think. Not me, I had it all planned out: I'd birth Ruby, bond with her, and then resume life as I knew it, writing, working, reading, going to movies and restaurants. Ruby would be nearby, strapped on to me like some exotic appendage, delightful, lovely, and obedient, living *my life* with *me. "Wow!"* people would exclaim, *"and you're a mother, too!" "Yep,"* I'd grin, *"Ain't I amazing?"*

At the same time, I had grown up in a family, so I wasn't totally in the dark about a mother's life. My mother, Suzanne, was the force in our family, the major dude, the maypole around which we four children swung. Her life was a flurry of car pools and food fights, telephone calls, trips to the market, little yellow raincoats hanging from hooks, packets of lunch meat, and Kool-Aid. She cooked practically every meal we ever ate, she cleaned, drove us to every conceivable after-school activity, tucked us in at night, applied bandages to hurts, drank, yelled, slammed her fists down on kitchen tables, baked birthday cakes, and took us to Dodger baseball games. We loved her, we were scared of her, and we idolized her.

I'll never forget those weekend nights when she and my dad, Wally, were on their way out to a party. The four of us would be sitting at the kitchen table delicately picking at our turkey TV dinners. My hungry father, dressed and ready to go, would be scrupulously tasting all of our food to make sure that nothing was poisonous.

We'd smell her first, her Arpége perfume wafting into the kitchen. Then the bedroom door would be flung open and there she'd be: Miss America! Beautiful, fully made-up with red lipstick and false lashes. Her hair was piled high, and she'd be dressed in something beaded and magical. She'd descend on us with big smiles and arms open wide, like a queen greeting her subjects. We were swept away. "Oh, Mom. *You're so beautiful. You smell so good. We love you so much. Can we have that dress when you're done with it?*"

I guess I imagined that my life would resemble hers to some extent, though of course I'd be *so much better* than she was. I wouldn't talk on the phone all day, wouldn't pick my kids up late from school, wouldn't grit my teeth, lose my cool, or slam my fists down on kitchen tables. I'd be the perfect fairy mom, so sweet and gooey with love and understanding that you could spread me over a muffin.

And then, one June, Ruby came.

Applause, curtain down.

Now it's November. It's cold and rainy outside and Ruby is five months old. She and I are sitting on the couch nursing—*again*—for the kizillionth time. The beautiful child and me, hair askew and still wearing the same baggy clothes I've been wearing for months, just sitting there, staring out the window into my untended garden.

"My God! What is this?" I gritted to myself. *"I've been sitting on this couch for five months. I smell bad, I can't fit into my jeans, and I haven't showered for days. It's too much of a hassle to leave the house with her because all she wants to do is poop, pee, and eat, and every time I do leave I feel compelled to spend money that I don't have because I'm not working! Aaackk! What the* hell *is going on here?"*

I couldn't remember spending this much time sitting still in my whole life. Anchored to the couch, I thought back to the many times I'd tried to meditate and how, after about two minutes, I would invariably start wondering whether the mail was in or what I might fix for dinner. But as I gazed out into the cosmic fog of my motherhood, I began to wonder if maybe there wasn't a lesson in this for me. Maybe motherhood was an opportunity to face certain things that, under normal circumstances, I'd

13

want to avoid. Like sitting. And just being. With no agenda and no get up and go. I always knew I'd be a workaholic if given half the chance, but I didn't realize how completely my work had defined my sense of self. Sitting on the couch in sweats, with my hair askew, I felt like nobody.

And yet, here was this beautiful child nursing at my breast. This darling, tender, sweet girl who had come out of my belly, whom I had nurtured and loved all those nine months, whom I had gone through the excruciating birthing process for. I loved her more than anything I had ever loved, and yet I wasn't so sure how much I actually loved *motherhood*. Friends envied my picture-perfect family, but I would have given anything to be dashing down some city street, manuscript in hand, ready to meet my editor with another brilliant work of art. Success, completion, productivity were like some rare air to me. I wanted them so badly.

Sitting there, day after day, nursing Ruby, I began to understand the complexity that is motherhood. It is more than shiny little raincoats hanging on hooks, more than sweet kisses and night-night stories. And as beautiful as it could be, it is also demanding, tiring, and frustrating. But unlike the other commitments in my life, like my work and even my marriage, which are things I had felt I could walk away from if they got too difficult and painful, I was never going to walk away from Ruby. I had to stay put and nurse and pump and change diapers, again and again, day after day, and I realized that motherhood's commitment was an opportunity for me to peel back some of my life's more surfacy layers and have a peek at what I was really made of.

At the same time, I began to reconsider my husband's suggestion that I write a book about motherhood. In fact I had a lot of questions for other mothers, and suddenly I wanted to meet other mothers very much. So, tape recorder in hand, I traveled to various parts of the country, seeking them out. I met as many kinds of mothers as I could: gay, straight, Black, White, teenage, over forty, single, rich, poor, happy, frustrated, content, and confused. I spoke to more than seventy women before I selected the thirty who appear in this book.

I wasn't as curious about their various mothering methods as I was about their personal challenges and how they attempted to find balance in their lives. I wanted to hear about the complexity of their own mother-love and I wanted to try to understand the paradox of wanting desperately to be with their children and as far away from them as possible in the same moment, which was a sentiment shared by almost everyone I met.

My first question was *"If your child is a gift from God, what lesson was he or she sent here to teach you?"* Then we took it from there.

Some women talked about self-esteem, some about leaving or staying at their jobs. Some talked about their relationships and how they handled their anger and frustration. Some women spoke of their own mothers and the emotional inheritance that they brought into their new families. The subjects of drugs, death, divorce, and sexuality all came up. We also talked about love, the very particular, full-bodied, heart-wrenching, breath-stopping kind of love that a mother feels for her baby. Many of us agreed that the word *love* doesn't do justice to this feeling. It isn't that the word itself isn't strong enough, but that it isn't complex enough to contain all the myriad feelings we have about our children.

If I came away with anything, it was a deep affinity for mothers, an incredibly underestimated bunch of warriors, who are, as one woman in this book says, like saints walking on water. I agree.

Twenty months into Ruby Grace's life, I'm still understanding my own lessons. I know I've learned something about patience and letting go, but I'm learning something about humility, too. I am beginning to accept the fact that I am not a METEOR OF A WOMAN anymore, and that I do spend a lot of time wiping gooey green stuff off refrigerator doors, that I'm exhausted at the end of the day, and that sometimes I lose my cool and am far from perfect. Most importantly, Ruby Grace is not an item to be checked off my list; she is a child, and she needs me to leave my adult pleasures and neuroses behind a lot of the time. And as hard as that can be, there's some relief in it, too. The air isn't as rare, but there's nothing like the feeling I get when she shouts *"Mama!"* and grins when she sees me first thing in the morning. I'd trade all the success I've ever known for that. Almost.

These stories are about a complicated kind of love. They're about the good, the bad, and the ugly that is motherhood. And they're about a full-bodied bond that takes you to a place called motherland, a place from which you will never return.

—Laurie Wagner, February 1997

JUDY HENRY

JUDY HENRY, THIRTY-TWO, IS THE SINGLE MOTHER OF HANNAH BLAIR HENRY,
WHO IS FIVE. JUDY IS A SURGICAL TECHNICIAN AT A HOSPITAL,
AND THE TWO LIVE IN A SMALL SOUTHERN TOWN.

Oh, Lord, I'm so ashamed, but I cannot stand Barbie Dolls. My little half-sister had every Barbie thing imaginable, but I have always detested those dolls. I can't stand them. They're not real, they're prissy, they sit back with their large breasts, perfect hair, perfect wardrobes, and they make me mad. And wouldn't you know it, Hannah is completely hooked on them. At last count she had twenty-three Barbies, and just about everything else they sell: the big doll house, the carriage, the car, the walking horse, and about a million ball gowns.

So that's one thing I will not play with Hannah. I tried to play Barbies with her, I tried. But I found myself hanging the little clothes on the coat hangers and making the little beds, you know . . . anal Barbie. But that was no fun. And then Hannah will want all twenty-three Barbies to participate and they all have names, and I'm sorry, I can't remember all their names.

When I used to play, I played with the Belle Barbie. She was my favorite because she wasn't the blond bimbo Barbie that all the rest of them seem to be. She has brown hair and brown eyes. She's even a little wider in the hips, and some of those gowns don't always fit her right.

When Hannah wants me to play, she'll say, "Mom, I'll let you be your favorite one." I know these dolls mean a lot to her—and I imagine it could be a good learning thing for her if I played more. I could make one of the Barbies say, "Oooh, well, that wasn't very nice. I think you hurt that one's feelings when you told her you hated her dress"—you know, like they do on TV. But when I get down to play, I'm so childish and immature about it. I instantly make them pick on each other or sing funny songs that irritate Hannah. I'll make one say, "Oh, no! Don't do that, don't put the baby in the oven!" And Hannah will say, "Mom! That's not how you play!" Then she becomes the adult in the situation, constantly chastising me, saying that Amy doesn't like to sit on the sofa and Beauty doesn't like to wear shorts. I don't know, I tried. I just don't think I'm a particularly Barbielike person.

Maybe it's because I'm so tall and big boned.

At five feet eleven, I'm taller than the average man around here, and I've never felt really feminine. To this day, when I put on makeup and fix my hair, I feel like a kid playing dress up, always wondering if I've done it right.

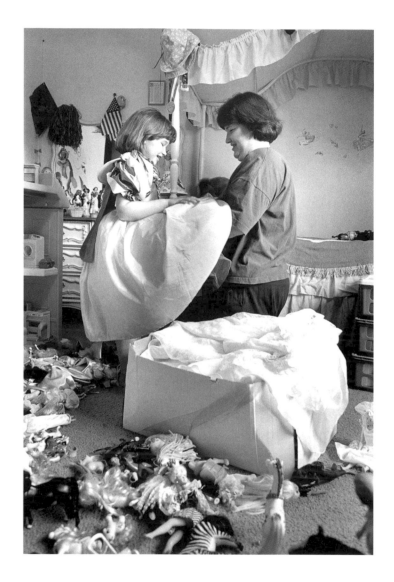

Some people say having a baby makes them feel more womanly,
but I didn't feel that way. I just felt larger. And it was scary having such a small thing dependent on me because I didn't know the right thing to do with her all of the time.

It was Hannah's father who got me to go to the childbirth classes when I was pregnant, and he was the one who was adamant that I breast-feed because he said it was natural and normal. I'm generally too inhibited and self-conscious for all that stuff. I mean, I was the one who left the room in birthing class during the birth part of the film.

It's funny, because her dad was a great influence on me during the pregnancy and her first few months. It's too bad that we can't combine our efforts and live together and do things for Hannah, but he just hasn't grown up. He likes to paint, and everything else is just to get by so he can do that.

We go through periods when he sees Hannah, and times when he doesn't. I try not to say derogatory things about him because he's a good guy, but on the other hand, I try to be as honest as possible. I let her know that he loves her and would like to spend time with her, but that Mommy and Daddy didn't get along because Daddy didn't want to work and Mommy couldn't afford to pay for Daddy's paints *and* Hannah's diapers.

I've even paid for his gas and given him whatever money he needed just to get him here, but that's ridiculous. If he was any kind of a father, he'd come on his own.

So being a single mom doesn't seem like that much of a big deal to me. It's been that way from the start. I'm pretty good at it. I'm good at the providing part, making sure she has everything. I'm not so good at the patience part, the carving-out-time-just-for-Hannah part. When I come home from work I'm tired, and by the time I've fixed her something to eat, done the laundry, helped her do her homework, and gotten everything ready for the next day, it's bedtime. So there isn't much time for anything else.

Recently she said, "Every time I ask you to play, you tell me you're busy, and that we'll do it later." And I felt awful hearing that because it makes me question whether I've put too much emphasis on whether her clothes and the house are clean.

Maybe it doesn't matter whether the carpet is vacuumed.

If I'm sitting there playing cards with her, she'll turn out better than if she's playing alone while I'm cleaning the floor so she'll have a good spot to play in.

I've loosened up though. I can actually go to sleep at night knowing that Barbie Dolls cover my living room floor.

I guess the best thing about having Hannah is that she helps me see the world through a child's eyes. I remember when I was small, it seemed that the things that made the world right were so totally simple—like the feeling of the sun shining on my face, or how cold and sweet an ice cream tasted, or how great it was to reach into a berry bush and cram berries into my mouth. This is all before I was old enough to think, "Gee, I really should have washed those berries," or "I can't eat that ice cream because it's fattening." **When you're a kid everything is just there, you take it, and it's great.**

So Hannah gives me a chance to feel that freedom again, and she catches me when I'm caught up in the petty, materialist rush that I think everybody's lives have become nowadays. I mean, sometimes I'm so far away from her joy.

Like maybe she's painted something and she's showing it to me and she's thinking that it's the best thing she's ever done, but I'm looking at her clothes in horror because those weren't the washable paints I gave her. That outfit is supposed to last until next summer and those white shoes will never be white again.

My first inclination is to say, "Oh, look at you, look at the mess you made. I'll never get those clothes clean. Now I'll have to buy something new. Do you know how long Mommy has to work to afford new clothes?" And then it slaps me because her face immediately crumples and she wails, "But my picture!"

I've gotten better because I've made her face crumple a lot and anyone who has felt the slap as a child recognizes that in their own child, and it feels terrible because you can't take it back.

You promise yourself that you're not going to do certain things that were done to you as a child, and then of course you do them. It's all in an effort to do the right thing for Hannah, whether it's working a lot so she can have things, or spending my free time cleaning instead of playing. But I live by the clock and I can only do so

20

much. I guess that's part of being an adult—which can be a drag—it's definitely a loss of freedom for me and not always fun.

Before I had Hannah, I drove my dad's old rusted Toyota. There was no air conditioning, and you had to play the radio real loud if you wanted to hear it, but it was perfect. I'd zoom along the levy at seventy miles per hour, not worrying if the gravel chipped the paint; I was going where I wanted to go and getting there fast. I didn't buckle up, I never worried if I had enough money. I'd throw my cash on the passenger side of the car, and if I needed money I'd just rummage down there and get some. People made all sorts of fun of me.

But when Hannah was born I needed a car with a back seat because it was safer for babies, and it's easier if you have that second set of doors. So suddenly I had a sedan! I patted myself on the back because **I felt that I was doing the right thing, buying that boxy-looking four-door car with the air bag and the special safety straps. But a part of me, the wilder, carefree part of me, disappeared along with that Toyota.**

And I don't ride down the levy anymore, either. I'm terrified every time I think I hear a rock. Even Hannah's scared. We'll be riding along and we hear a click and she'll say in this horrified little voice, "Was that a rock hitting our car?" Now that I'm paying $230 a month for that car, I'll be dammed if it's going to get torn up.

So I guess you make your choices. Part of me longs for those days when I only had me to take care of. It's a change getting used to having another person in your life all the time. When Hannah was one or two years old we might drive an hour to go to school or to work, and it never occurred to me to speak to the child. I was just so used to being by myself. Now I have to remind myself to talk to her on those long drives.

I hope that if Hannah gets anything from me, she'll realize that just because I'm her mother, I'm not perfect, and sometimes I make mistakes. Sometimes I'll yell or lose my temper or be unfair, but I always tell her when I've been wrong. I tell her that it's just as hard being a mom as it is being a kid sometimes. I don't have all the answers, and **I'm doing the best that I can. I mean, I'm not Barbie.**

21

PEGGY MOTLOW

PEGGY MOTLOW LIVES IN A TINY TOWN IN THE SOUTH WITH HER HUSBAND JOHN AND GRANDDAUGHTER TAYLOR JORDON, WHO IS SIX YEARS OLD. PEGGY AND JOHN ADOPTED TAYLOR WHEN SHE WAS TWO, BECAUSE TAYLOR'S MOTHER PAYTON—WHO IS JOHN'S DAUGHTER— WASN'T READY TO RAISE HER. PEGGY IS FORTY-EIGHT AND HAS ONE BIOLOGICAL CHILD, KRISTIE, WHO IS TWENTY-EIGHT. KRISTIE HAS A YEAR-OLD SON OF HER OWN.

After my kids left home, I used to sit here in the country with nothing to do all day but clean my house and watch TV soap operas. And I'd just pray to God and say, "God, if I had it to do all over again, I would do it so differently. I'd be more loving and more patient. Please, God, just give me a chance, maybe one more chance to show you that I could be a better mother."

But of course that wasn't going to happen because I'd had a hysterectomy and I just thought that part of my life was over. I never dreamed I'd be raising a child again at my age. Never.

And then Taylor came into my life and, well, here I am, nearly fifty years old, volunteering at school fairs, baking cookies, buying Barbie Dolls, and planning birthday parties for six-year-olds. I almost wish I'd waited this long before I had my first child because I realize the best age to have a child is at least forty. You know yourself better and you've learned from your mistakes.

Taylor was like a gift

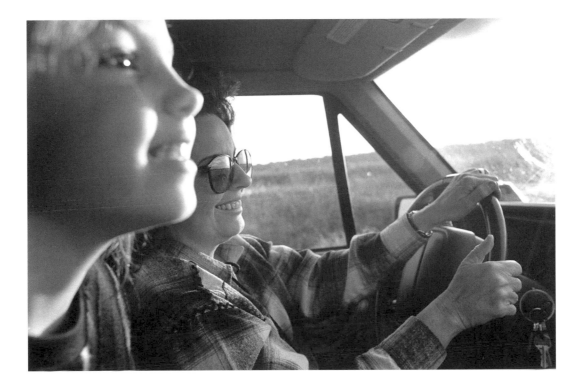

How I came to be Taylor's mother is an awfully long story, a regular TV drama with a cast of characters that included a mother who wasn't ready to become a mother, a father who wasn't really the biological father, too many court dates, some swindling, and a lot of pain for two grandparents who desperately wanted to bring a little girl home to live with them.

The short version is that Payton—my husband John's daughter by a previous marriage—whom I had raised since she was five years old, had gotten herself pregnant by this fellow while they were in the military, and when they split up he managed to get custody of Taylor, who was only one. He was a real strange guy and never let us see Taylor, but when we found out that he wasn't Taylor's real father, that Payton had been mistaken, well, that's when John and I set out to adopt the little girl. I mean, she was ours and since Payton—who I love dearly, but who doesn't have a maternal bone in her body—said she wasn't ready to be a mother, and since John and I could never have any children of our own, Taylor was like a gift. And for me, well, **she was a chance to redeem myself.**

What I'm trying to say is that I hadn't exactly been the best mother the first time around. When I had Kristie, my first baby, I was just eighteen years old, fresh out of my mother's house and married to someone I never should have married. I'd left home because I wanted to be free from my parents and on my own, but I had no idea that being a wife and a mother was about as unfree as you could get.

Oh, I went through the motions of motherhood. I tried to do it all and be like those perfect TV mothers. I fed Kristie and I made sure she had clothes and that she got to school on time, but I wasn't loving or tender with her. Mostly I remember feeling burdened and, to be honest, wishing that I didn't have a child, so I could go to college and have fun like the other girls my age. And maybe I pushed Kristie away a little bit too—you know, by being emotionally absent and by making her do things like get her own breakfast and dress herself even when she was a little child of three because I didn't want her depending on me so much.

When she was two and a half, my marriage ended. I was twenty-one years old, just a child myself, and I wanted to be with my friends. So I'd drop Kristie off some place and let her be taken care of by whoever I could find, so that I could run off to parties and bars. It wasn't a very emotionally stable time for me; I was in a million other places instead of being home with Kristie.

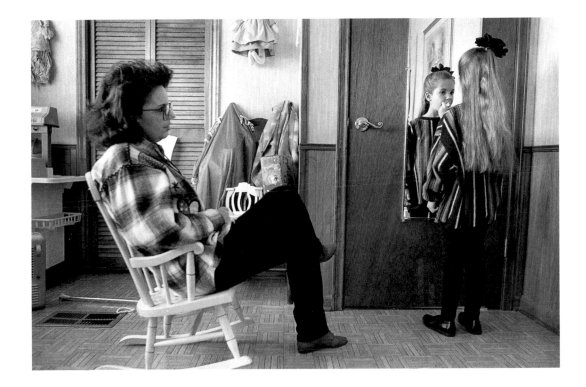

My second marriage was pretty bad, too. He was an abuser and it only lasted a year. My mother would always tell me that the one who was hurting from all this was Kristie, but **I thought that her being with me was enough.** I never thought about the impact my life might have on her.

When I married John, my third husband, he brought Payton along, so now I had two little girls who were five and six to take care of. I was still a little wild, and probably controlling, and still wishing that I had my freedoms, so the first three years were tough on me.

What I didn't realize at the time was that I was having some kidney problems which made me real tired and not a real happy person. It's not that I was any worse than any of the other mothers out there, but I screamed a lot and felt frustrated most of the time. If the girls said anything that I thought was bad, I freaked out. They weren't allowed many freedoms either. I think they were more scared of me than anything. I never beat them, but just my loudness, that's what got them. Now that I look back on it, I think the fact that I never got a break from mothering was what made me so crazy. John was working all the time, and the girls just seemed to demand so much. I always felt that they were stealing the life away from me. Maybe the girls today who have careers and that sort of thing make better mothers just because they've got something besides those children all day long.

But the other thing which contributed to my madness was that, because of my Catholic upbringing, I just figured that I was going to hell because of my divorces. That's what my mama told me anyway. She had some very strong opinions about the way things should be, and she felt that the true way of living was to get married, have a baby, and that's it. So when I did something against her, like having two divorces, all she could say was, "You made your bed, now lie in it." At the time, she never saw that my marriages were abusive and wrong for me. I think part of the reason I just went through the motions of motherhood was because I figured, "Well, I'm already going to hell. God will never forgive me, so why try to be a better mother?"

It was only after the girls left the house seven years ago, after they were grown, that I realized I really missed them. I know that must sound crazy after all I've said, but even though there were many times when I didn't want them around, I came to realize that my whole life depended on being their mother, because that's all I'd ever been, a mother. My sister says our mother made us codependent on our husbands and our children, but honestly, **being a mother and a wife was all I ever wanted to be, even if it did take me three marriages and thirty years to get the particulars right.**

26

So I got to thinking during those seven years of cleaning my house and watching TV soap operas every day, and maybe you could say that I grew up some because I realized that maybe I hadn't been the best mother to those girls, and even though I don't regret the marriages or the kids, because I learned from all of it, I did begin to see how I might have done things differently.

And then God gave me Taylor, to show me that I could be a good mother and to prove to myself that I'm not such a bad person after all.

And I am a completely different mother today. I'm more relaxed and the things that used to bother me, like Taylor following me around the house all day, just don't get to me anymore. When my older girls followed me around I'd scream, "Can't I just go to the bathroom and have some peace?" Then I'd slam the door on them.

I see these young mothers today screaming at their children and I feel like I'm looking at myself fifteen years ago and I tell these mothers, "That's not going to work." And they say, "But I don't know what else to do! These children are driving me crazy!" And children will do that, but I think the calmer you are, the calmer they are. I tell you though, it's taken me forty years to just relax and see the bigger picture in life. **You know, the sun doesn't rise and set because my kitchen is clean or because my kids ate all their peas. Tomorrow is another day, relax, your kids will turn out fine.**

And because I'm more relaxed, I end up giving more of myself to Taylor than I ever gave to my other girls. It's a more patient kind of love. I spend time with her and share things with her, whereas before, if I fed and clothed the girls, I assumed they knew I loved them. But children want you and they need you. Feeding and clothing them is a duty, not an act of love.

Of course, Taylor is a child and she tries to see what she can get away with. My friend Beth says **she yanks my chain,** and I guess Taylor is a *little* outspoken and will let me know when I haven't done something right, even if it's as simple as not putting her pillow back in the right place on her bed. And sometimes I'll say, "Oh, my God! What just came out of that child's mouth?" when she tells me that she doesn't like her supper. But I don't jump on her like I would've with the other girls and say, "I can't believe you said that!"

When Payton and Kristie come around they say, "Boy, Mama, if we'd pulled that stunt on you, you would have had a fit. You didn't let us get away with that stuff." And they're right. I feel bad that it's taken me so long to get the hang of mothering, but I wouldn't have learned it if it hadn't been for them. I don't like to think of Payton and Kristie as guinea pigs or anything. I wish I would have been like I am now, but I wasn't.

I've apologized and told them I was sorry, and I think they've forgiven me. Most importantly, I've forgiven myself.

27

VIVIEN DAI

VIVIEN DAI, TWENTY-EIGHT, IS A DANCER AND MOTHER TO
BRANDON SKYLER, WHO IS FOURTEEN MONTHS OLD.
THEY LIVE WITH VIVIEN'S HUSBAND, JAY LASKO, AN ACUPUNCTURIST.

What's it like to be a mother? Well, today we woke up late and I rushed Brandon into the bath. Normally he's a very calm child, but today he was a screamer, and as I was trying to get him bathed I thought, "I'm going to end up answering the door in a bathrobe. How perfect for this interview and how very real."

Part of **motherhood is getting real with yourself.** It's stripping off the labels and the images of what you think you should or shouldn't be doing and who you think you are.

Before I had Brandon I was very self-centered, like most people in their twenties are. I was a dancer and trying to make that my career, and Jay and I had a really easy life together. We spent our time going to cafes, or taking walks, snuggling and talking.

Normally he's a very calm child

But after we had Brandon, all that changed. One of the most vivid memories I have is about a week after he was born. Jay was finally leaving the house for work after staying home and taking care of us all week. We'd had this wonderful water birth and the whole house felt just like a big, warm womb. I hadn't even stepped out of the house all week. So there I was, standing at the door with Brandon in my arms, waving goodbye to Jay. The screen door was between me and the outside world, and all of a sudden I had a nervous breakdown. I felt like I was waving goodbye to my old self. I mean, I was a dancer, an artist, I'm supposed to be out there in the world, and all of a sudden I'm here with this little being who's totally dependent on me, and I didn't know who I was or what I was supposed to do next.

I guess I never imagined the logistics of motherhood. I didn't think about identity crises. I didn't think about the crying or the sleepless nights. I thought, "I'm going to be a great mom. I'm going to love my kid and I'm going to be able to handle it all. And if I can't, I'll push myself to the limit to be able to."

So here I was raising Brandon, doing the laundry, cleaning the house, doing the dishes, the grocery shopping. I even found myself ironing Jay's shirts—which he didn't want me to do—but I said, "Hey, I'm the housewife. Let's be the ultimate housewife! Let's iron the fucking shirts!" I think I went a little nuts because I wasn't out there working and making money and I felt I needed to justify staying home by being so over the top.

I'd had this wonderful conversation with a woman from my yoga class a few weeks earlier, and she'd said that although it's very difficult to be a mother, what could possibly be more important than honoring my home and family by feeding them and taking care of them? So for a while that became my justification for trying to do it all.

You should have seen me during the first three months. Every time Brandon would fall asleep I'd race around the house trying to get things done. I'd go into the kitchen and start doing the dishes, then I'd find myself in the laundry room folding clothes, which would carry me back to the baby's room where I'd clean up the mess in there, and by the end of the day I'd started ten different projects but completed none. Jay would come home, look around the house and ask me what I did all day. Oh, we got in some marvelous fights. One day I said, "Don't fucking ask me that! I work my fucking ass off! I don't know what I do all day but I do it!"

29

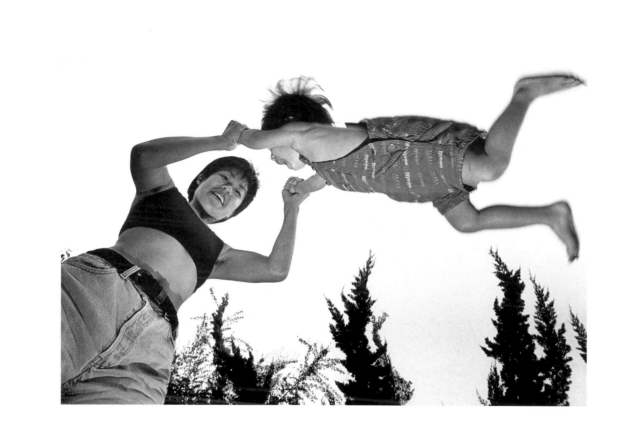

Fatigue is my worst enemy. Whenever I push myself too far, or if I'm tired or on the verge of catching a cold, I crash. I just sit down and cry and think to myself, "Did I ask for this?" One time the baby had been sick with the flu and he hadn't slept for four nights—which meant I wasn't sleeping. I finally put him down and came out of the bedroom and looked at my husband and said, "I'm going to slit my wrists." And he laughed and said, "What would that do?" And I said, "Because then I could just sleep." And I was totally serious.

It's not like I wish that Brandon hadn't been born. It's not that at all. I love Brandon so much, but there are days. I remember talking to other mothers before I had him and they'd say, "Sometimes I want to throw my child out the window." And I thought, "I'll never get to that point." But honey, I've been there. And it's usually when I'm tired.

I think my biggest fear was becoming a housewife and staying home in the suburbs, getting fat, having ten kids, and losing my dream of dancing. And here I was moving in that direction. Being the housewife became so isolating for me, and maybe that's why I experienced this identity freak-out.

The turning point came on one of the few dates that Jay and I have had. We'd gone to a dance performance, and I sat there watching the dancers and just shaking in my seat because I missed dancing so much. My soul was up there dancing with them, and I realized that I couldn't deny that part of myself anymore. So I start taking classes and even recently auditioned for a company. It's funny, because it's okay with me if I don't get the job. I think most of all I needed to keep the possibilities open and know that I could return to dance someday. Maybe now is just not that time.

In his own way, Brandon has taught me many lessons. Certainly in the **areas of patience and surrendering** and learning how to be more present and not wishing I was doing something else. On those days when I'm racing around the house trying to get things done, and he's crying because he wants to go out, I'm learning to stop and say, "I understand why you're upset. I'd love to be outside. Let's get out of here. Let's just forget about the dishes and the laundry and tonight's dinner. Let's go to the park." And I'm grateful to him for this because I'd probably be a lot happier out there, too.

31

MARSEA GOLDBERG IS A FORTY-YEAR-OLD ARTIST AND GALLERY OWNER.
SHE LIVES WITH HER THREE-YEAR-OLD SON AUGUSTE, AND HER
HUSBAND STANLEY, AN ARTIST AND ANIMATOR.

I've always been drawn to down-and-out characters like alcoholics and people with problems. It's that maternal instinct in me, that ability to nurture people. But since I had a kid, I can't bail people out like I used to. I don't even rescue pets anymore—well, actually, I take that back. I did rescue a dog a few months ago. But I just don't have the time for that stuff anymore. I had this drunken friend, but after Auguste's first birthday he got worse, and we just kind of drifted away from each other.

My friends either seem to be divorced, single, or gay, and I love them because they bring out the artist part of me—the real me. But after I had Auguste...well, they didn't exactly dump me. They tried to support me, but I think they were kind of disgusted, because they didn't want to hear about diarrhea coming out the back of the kid's shirt or what I go through in a cooperative nursery school. They want to see the beauty in life and they don't want to know about mommy stuff. I'm still tight with a lot of my crazy friends, but it's a strain to be on the party list these days.

I think they were kind of disgusted

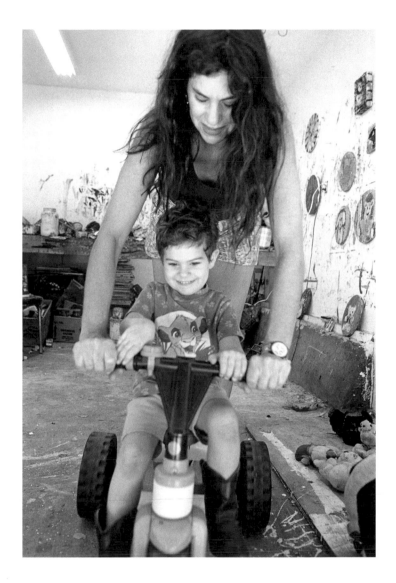

Now what I look for in people is total kindness and people who love animals and who are great with kids. I've befriended a lot of polyester mamas who I wouldn't normally know, but who are really nice people. Having a kid takes you into new worlds.

Like when they're first born, you get back into that whole hippie thing, thinking that everything has to be natural and organic and perfect. Once I was at this really funky, hippie health food store and this ogre of a woman, who I think was being paid to sweep the streets, comes up to me. I was really leery at first—I mean all her teeth were decaying and she was kind of a monster. But she comes up to me and she says, "Is this your only child?" And I said, "Yeah," and she says, "You won't need another child because this child has everything." Then she said, "Some people have more children because they're not satisfied and they need more, but you won't." And I was floored because those were absolute pearls of wisdom and I knew she was right.

Auguste *is* perfect for me. Besides being this really cool kid, he has this incredible goodness and way of filtering out anything bad. He focuses on the positive, whereas I tend toward impatience and depression. He's filled a hole in my life and taken away a certain amount of frustration and emptiness that I never would admit to before.

He was born at a time in my life when I was conscious of losing people. My mother had died and so had some friends. Before their deaths I had no idea about death behind my shoulder, but when people who you were just having coffee with or who are members of your family die, you realize, geez, it's kind of weird and hard to make sense of it. I needed to find a way to understand it, and having Auguste helped remind me that people come into the world and people leave it. He became life-affirming.

He also brought a newness that I really needed. I guess I feel like art isn't quite enough of life. **There are always new people and new art, new shows and new museums, but it's nice to have somebody who you can teach it to and who can carry it on.** Since having Auguste, my life has become so much less about me, and I needed that because I was starting to feel that I was a taker and that maybe it was time to nurture somebody else.

There were whole years when I'd paint eight to ten hours a day and wait tables at night and come home real late. I traveled a lot. I went to Africa by myself and almost stayed to run an art gallery there. I lived with complete freedom. I was going to openings and hanging out with people and doing the coffee thing. Then a year before I had

34

He became life-affirming

Auguste, I found myself topless at the beach in Cannes, at the film festival, drinking Champagne and eating some weird French food and I said, "Wow, this is it. I've reached the top of the jet set. It can't get any better than this. I might as well have a kid."

Now I have to come home every night and make sure there's food in the house, and I have to cook and make sure that things are clean and that Auguste is clean. You know, **you hear all these stories, "Your life is going to change, blah-blah-blah,"** and I always thought, "I'm a really tough girl. I'm not going to get sucked into the garbage that all those wimpy housewives complain about. Nothing is going to change for me." And although my life *has* changed a lot, I haven't made huge sacrifices, because I'm a very stubborn person and I do things completely my way.

Like recently my husband and Auguste and I were on vacation in Hawaii and I was swimming back and forth in this bay for a really long time while Auguste and my husband played on the beach. It was really beautiful and there were all these fish, but when I looked up I saw that Auguste had started screaming because he wanted to be out in the ocean with me. But I just kept on swimming. I didn't swim back in and rescue him. In a sense I saw myself as his hero because he was in awe that I was swimming so fast.

I think it's important that a child knows who his parents are and what they are about instead of always seeing them through the tunnel of what they can do for him.

My mother always lived for her children and was very self-sacrificing, and I always used to say to her, "Why don't you do more for yourself?" So it's been important for me to show my child that I'm a person and that I'm not living for him—even though I probably love him more than I love myself. I just try not to make it obvious to him. There's a cutoff where I have to be myself, and sometimes that means that I disappear.

I don't want to come off like I'm a snob or that I'm better than other mothers. This is just who I am. I've always been different. I've always marched to my own beat. **Why should I change because I'm a mom?**

35

I saw myself as his hero

36

Josefina Bates, thirty-five, is originally from Colombia. She has two children, Felipe, who is five and a half, and Sebastian, who is fifteen months. She is an artist and is currently working on her MFA in printmaking. She is married to Buddy, a tour guide and student.

Josefina Bates

When I was twenty, I said that I'd never get married or have children. The last thing I wanted was to be in a family again because growing up was too hard; I learned too many truths too soon and I didn't want to repeat my family's drama.

I was raised in Colombia. My father was a typical Latin guy; he had children before he married, had kids with my mother, then, after they had been married twenty-five years, he gets a lover, which I found out when I was fifteen. I think after that everything fell apart for me. I felt like I could only trust myself, not my father, who became like a nobody to me, even though he was still trying to tell me how to run my life.

My mother was and is still very traditional. Of course she would never leave my father. I call her one of the last dinosaurs because she was taught that her job was to have kids. And even though she was a wonderful mother in many ways, and even though she raised me to go out into the world and think for myself, Colombia is a patriarchal society. So as free as I think I am, **I am still influenced by a society of women who were reared to be mothers and who were told to leave their personal needs behind** while their men roamed freely doing whatever they wanted to. The way boys are treated in Colombia is just something to see.

There's a popular saying in Colombia that goes, "I raise my boys the way I want to." It's a little crazy, but the psychology behind it goes something like this: it is understood that men are animals, that they are bad and will hurt you. They will take lovers and nobody will interfere, and nobody's political career will be lost for it. But the only man who will not hurt you is your son. So the mothers, they absorb their sons and they never let them leave the womb. They think that if they just keep them at home and do everything for them, then they will not be like Daddy who left me for a twenty-year-old.

As the mother of two small boys, my fear is to do what my mother has done. I already see myself doing too much for them. Sometimes I want to take them breakfast in bed and I have to hold myself back because, even though it is nice, if I don't have the time to do it for my husband, why would I do it for my boys?

I hug my boys, but I try not to love them too much. Let them have a real relationship with their daddy, let him take over sometimes. It doesn't always have to be me.

37

men roamed freely doing whatever they wanted

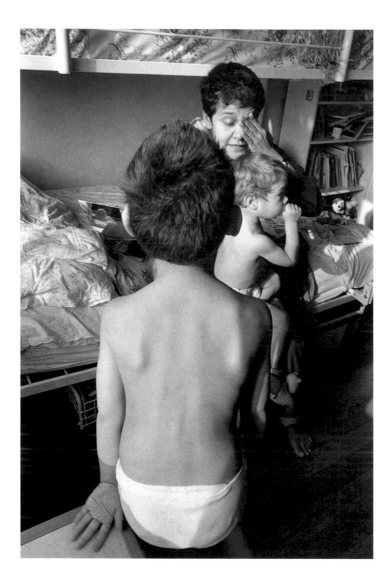

And I try not to protect them so much, like my mother protected my brothers. There is a family that lives close to us and every time Felipe approaches their girls, they never want to play with him, and I ache because I think that this must hurt him. But I'm not going to bake cookies and be friends with their parents just to buy their friendship. The parents, they never offer Felipe anything to eat or drink when he's playing with them. And when it's time for them to eat, they say "Felipe, we're going to have dinner," and they close the door on him. One day I said, "Come on Felipe, don't play with that little girl, she never wants to play with you." And he answered, "I'll change her mind." So I said, "Maybe you know something that I don't know—" and he said, "Yeah, I do." Felipe is a tough little guy.

I have learned that I have to be tolerant when my child gets hurt out there. When I see parents fighting their children's fights, when I see them act like "Hmmmph! You don't like my boy? Well then I don't like you!" I think they are very immature people. They are not growing and learning, and **if there is such a thing as reincarnation, then they will surely come back as stones.** They're not even going to make it back as animals.

As a mother, you rediscover many things you had closed yourself off from. In your young adult years you find out about friendship and how some people are not really your friends, and there are a lot of painful things you learn. In order to grow up, you have to become callous, to not get hurt. But when you have a family, you end up reopening those painful doors that were shut, and you cannot remain callous.

Trust, for instance. **If you're going to have children with a man, you have to trust him like you haven't trusted anybody before.** But it's a more mature kind of love that has to come into place. It's no longer only about me, it's about us, and you and me and what is good for the children.

39

When I was younger, it was me first all the time. When relationships would get too hairy and too complicated I was like "byyyeee." I used to say I wouldn't cry for anybody for more than a week. But there was so much vanity in that, thinking of myself as a beautiful woman who could get whatever she wanted. But as a mother I had to rethink myself into being a much more mature woman. When you have kids, you've got to work things out in your relationship, and when there is a problem, you have to talk about it.

There can be a lot of conflict in raising children, especially when you come from different families and different cultures as my husband and I do.

For me, I'm very loud. I scream at the top of my lungs, "Get down! Get down from there!" which is very ineffective, but that was how I was raised. I know that it's better if I stop doing what I'm doing and go upstairs and calmly say, "Felipe, please get down because it's dangerous and Mommy's busy."

I think the key to being a better mother for me has to do with my own personal peace and happiness. One of the things about being a grown-up is that you can't complain all the time about how hard life is because, hey, **you don't know, this may be the happiest time in your life.** If you're thirty-five years old, you have a pretty good idea of what happiness is. If you're still thinking you can really be happy, like a Hollywood love story happy, then you'll definitely come back as a stone.

For me, happiness is to know that I have a good system set up, and that the boys can go to day care, and that I can do a little something for myself. I feel happy if I can work out. I'm happy when we sit down and have a nice meal. And I'm happy when the checkbook is balanced, and when my husband is in a good mood.

I tell you, the life of the mother and wife is not an erotic, sexual fantasy. There is a loss to that side, the nice lingerie or nice conversations with your husband without interruption.

I feel good if I'm fitting into my old clothes. It's not about trying to be a cover girl on a magazine or being obsessed, it's feeling good about yourself, period. And you need to do things that make you feel good. Not that you're trying to be like Betty Crocker and live on a low fat diet your whole life, but you need to find some balance and a little bit of peace. These are the things that will make you a better mom.

"Get down! Get down from there!"

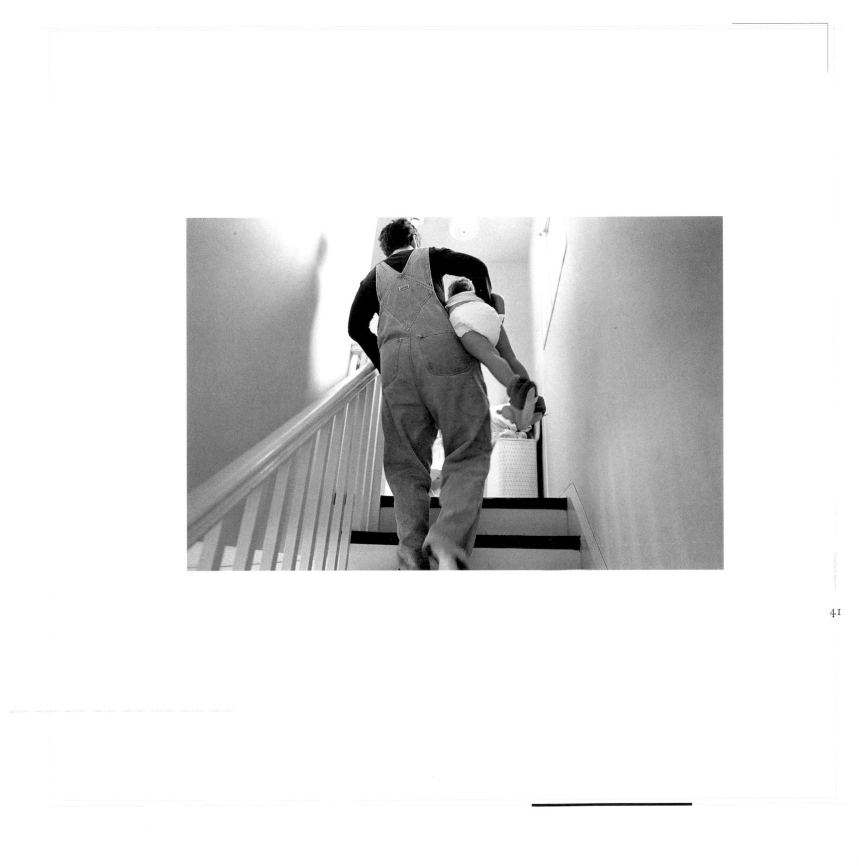

BERNI NASH

BERNI NASH IS MOTHER TO LIAM WILLIAM HENRY NASH, AGE TWO AND A HALF.
BERNI ADOPTED LIAM IN LATVIA BEFORE HE TURNED TWO. SHE IS SINGLE, FORTY-FIVE,
AND A REAL ESTATE AGENT.
SHE HAS ALSO WRITTEN A NUMBER-ONE COUNTRY MUSIC HIT AND
TRAVELED THE WORLD AS A STEWARDESS.

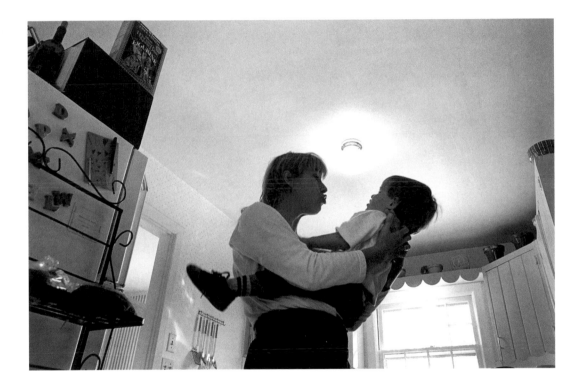

Mothers are amazing people. They're saints walking on water. I'm serious. For the first three months I had Liam, we'd go out into the world and I'd see a mom and I'd think, "Oh, my God! There's one now! She's got her kids with her! She's shopping and everything's under control! Unbelievable! What a saint!" And I wanted to go up to every one of them and say, "You are just so wonderful," because **being a mom is just a million times harder than negotiating a real estate contract or writing a hit song or studying for a physics test.** It's a lot harder than anything I've ever done in my life, and nobody tells you that.

I approached motherhood like I had approached all the projects in my life: I was very orderly and task-oriented, with goals and lots of lists. Even when I went to Latvia to get Liam, my attitude was, "Okay, we've got the bags packed, food in the pantry for when we get home, we've got diapers and milk. Okay, I'm ready to be a mother now. Let's go." I was very cerebral, and I figured I could bring that same formula for success to motherhood.

My parents came with me to Latvia to get Liam from the orphanage where he'd spent the first twenty-one months of his life. We drove for five hours in a Chevy van out into the poor, peasant section of the countryside to reach him. When we finally arrived, we were met by these big, old Russian women, real matronly with their aprons and big, red-apple cheeks—ruddy, laughing women with hefty "ha ha ha's." They were dressed in white nurse uniforms and had tight little buns on the tops of their heads. I felt like I could have easily been in a crazy house instead of an orphanage.

Anyway, it was a relatively clean place, so we sat down in the waiting room with three other sets of Americans who had also come for their children. The other women seemed motherly and ready, but I was just a nervous wreck. It felt like a curtain was going down on the last forty-five years of my life. We had a little cake, fruit, and vodka session, which must be the custom there, and all of a sudden, one of the big, matronly women steps into the room swinging this skinny, little child by the arms and everybody gasps, and then she disappears out the door with him.

None of us knew who this child was because they weren't telling us anything about whose child was coming first. I'd seen Liam's picture, so I knew that he was small, and that he had a nice smile. I also knew that he was the sixth birth to a mother who had

44

none of us knew who this child was

four other children at home and who was too poor to take care of Liam. Where the fifth child was, I'll never know. Maybe he died at birth, or was left at the hospital as Liam was, and eventually sent to the orphanage. You can't find a lot of detailed records because the Latvians are sort of back in the 1920s and 1930s in terms of progress, and there are lots of secrets and unclear things. Even when I said yes to adopting Liam, I hardly knew anything about him. Of course I'd hoped for a son who was amazingly perfect for me, but my expectations were much less because I'd seen other adopted children and some of them were slow—not real bright and shiny kids. I was even prepared for a child who was nearly retarded because there were no guarantees.

So we parents are sitting there twitching and sweating, and two seconds later this matron is back in the room and she swings this same little, skinny child into the room and right into my arms.

And there I was, holding this poor little thing who's got his arms tightly clasped around my shoulders, and **we were both shaking like leaves.** It was the most incredible moment.

I looked down and saw that his hair was short and scruffy like he'd been in prison, and he had a bald spot where he'd probably rubbed up against the crib to go to sleep at night. And he smelled pretty bad, too. Finally we looked at each other, and it was the weirdest, most wonderful thing. I'm thinking, "This is my child, the person who I'm going to be with for the rest of my life," and it was a lot to take in. We had to take his clothes off because the orphanage needed them back, and as we undressed him I saw that he had half of a little boy's T-shirt on for a diaper, and his legs were just a little bigger than my fingers—skinny, little bird legs. And he was so afraid, like an animal who'd been captured and was about to be put into a cage. He had no idea what was going to happen to him.

So I brought him home to Nashville.

And man did that blow him away.

The first day here, he just hobbled around staring at things. He wasn't a great walker because they hadn't taught him to walk until he was eighteen months old, probably because they like to keep them as stationary as possible in their cribs. So he was real unsteady, walking around with his skinny little neck jutting this way and that way, and

45

his eyes were as big as saucers because my house is pretty colorful. He looked like he was thinking, "Wow! Where am I? What is this?" And I kept saying, "You're here, Liam. You're in Nashville. You're home." But I was as wide-eyed as he was and as nervous as any new mother would be.

I mean, here I was forty-five-years old, single, with a twenty-one-month-old child. **The last time I'd changed a diaper was thirty-two years ago, when my sisters were little.** So my mom stayed with us for a couple weeks and showed me how to organize the food pantry and his clothing drawers and instructed me on what kinds of utensils a twenty-one-month-old child uses. I remember nodding at her and saying, "Uh, yep, that's a good place for that, Mom." I would eventually have figured all of that stuff out, but I was in a daze and just needed her support because **being with Liam was like hanging onto a wild tiger's tail**; he was sweet, but he was two, okay? He came with a personality and a will of his own. I was just trying to keep up with him—and we didn't even speak the same language!

I think he was babbling in Russian, and all I speak is English and French, so we sort of circled each other, Liam trying to figure out what was okay to do and what wasn't. Simple things like he'd rip a piece of paper out of a larger pad and then look at me for my reaction. Then he'd take that piece and rip it into little pieces and look at me again. Then he'd put all the little pieces in his mouth, all the while glancing up at me to see what I would do next. I was just trying to figure out what kind of a person he was and what my own mothering style was going to be, which is something that I'm not so sure I've figured out yet.

I think it's taken us a while to bond, too. One of my friends, who had also adopted, claimed that she bonded with her child in the first two days in the Latvian hotel room. So for the first few months I thought, "I may only be a guardian for this child. I may never be so madly in love that I'm going to drool all over him like so many women do over their kids." I'd get calls from my friends gushing, "Isn't motherhood just wonderful!" And I'd say, "Yeah, it's wonderful," but inside I only imagined how wonderful it *could* be.

46

It was tough. I had my lists and my goals, but after we'd gotten home from Latvia, it all started to unravel, and pretty soon I was saying to myself, "Okey-dokey, this isn't quite the same kind of gig as my last project." I quickly realized that **motherhood is not a very tidy little package at all. In fact, it's the untidiest of packages**, and there's no going from point A to point B. When things are black and white, it makes life so easy. But when you enter the gray zone—which is motherhood—my lists and goals couldn't really help me out.

Here I'd been thinking that adopting a child would be a good thing for me to do. You know, I'll help this little child who has no family, and this will be the first unselfish thing I've ever done in a life that was mostly about me, me, and me. I'd been a stewardess, I'd traveled, I'd been successful in the music business, had a successful career in real estate, a beautiful home, been married twice, and was always only thinking about the next thing that I would do for my own pleasure. Adopting a child was, among other things, a chance to finally reach out and give to the world that I'd taken from. But I was also looking for a kind of love I imagined a parent and child had. It was an intimacy and a closeness that I think I needed in my life. I hoped that Liam and I would love each other, but I also didn't want to be let down in the case that we didn't bond, so I think I stayed in my head most of the time.

Then in the third month Liam got sick, and this one night I held and rocked him in my room until the sun came up, and I thought, "This is better than sex with Sean Connery. This is better than anything I've ever felt because I'm a mom now, caring for this little being who the universe has entrusted to me and somehow I will figure out how to do this." And at that moment I felt little tendrils of a plant encircle me and Liam and that's when our bonding began.

As I look back on it now, I realize that even though I didn't have any idea how gray the gray zone of motherhood would be, I realized that I needed to step into it.

> **I needed to have a more soulful approach to life and throw away those stupid lists.**

I don't know if I'd call myself a full-on saint yet. I don't walk on water or anything. Maybe I'm the black sheep of saints. I'm the one with the exercise outfit on underneath my robe, I've got the glass of wine in my hand, and I'm trying *real* hard. I'm not as good as the other saints, but I will eventually get the knack of this, and I will find my place in heaven.

47

Maybe I'm the black sheep of saints

SARAH ROTHENBERG

I met my ex-husband in the first grade, the same year that **we were king and queen of the school play.** How's that for a beginning? So by the time we met again many, many years later, it felt like destiny, like we were supposed to be together. We moved in four months after we remet, and two months after that I found myself pregnant with Maddy.

Looking back, I would have done a thousand things differently. But at the time, I threw myself into the relationship because David felt like the person I was supposed to be with. You know that book by the radio psychologist Laura Schlesinger, *Ten Stupid Things Women Do to Mess Up Their Lives*? I could have been in that book. Sometimes I imagine what I would have said if I had actually called Dr. Laura during that time: "Hello, Dr. Laura, I'm twenty-seven, I just met this really great guy, but he's ten thousand dollars

he was still unhappy, so he left

in debt and fifty pounds overweight. Should I shack up with him? Should I get pregnant by him? Should I just overlook those issues and hope that they never emerge during our marriage? I mean, darn it, we were the king and queen of the school play! It's meant to be! It's spiritual!"

I swear, for so long, I lived my marriage as if it was God's plan.

Then, when Maddy was two, David said he wanted to leave the marriage because he was unhappy. We did some therapy, and I thought we were doing great. I was really invested in staying together because I loved David and felt we could work out our problems. But he was still unhappy, so he left. That was two years ago.

People think that when you divorce you end your relationship, but when you have a child, it just continues in another form. And you have to work on your divorce just as you worked on your marriage, if you want to have a happy divorce—which is challenging. When you're married, you're more willing to compromise and find agreement because you want to go to bed speaking to each other. But when you're divorced, there's little desire to work things out, and you're more willing to say "fuck off!" Part of you just doesn't care anymore.

But since we have a kid, we have to keep caring, even if we don't want to, because we love Maddy and she's going to be a lot healthier and happier if David and I make an effort to be friends.

So when an issue arises and we disagree on something related to Maddy, whether it be about visitation schedules or making joint legal decisions together, before we even get close to a fight, we get ourselves to our therapist, Valerie. The hardest thing for us has been to really be able to hear the other person. It's easy to question whether the other is doing something because we're divorced and we're trying to get at each other, or because it's best for Maddy. And since Valerie has Maddy's best interest in mind, she helps David and me come together and make good decisions.

I'm very sensitive about divorce. My own parents divorced when I was eight, and it shattered my world. I'll never forget the night my dad said goodbye to me and left our home. I remember crying because I loved him so much and didn't understand what was

49

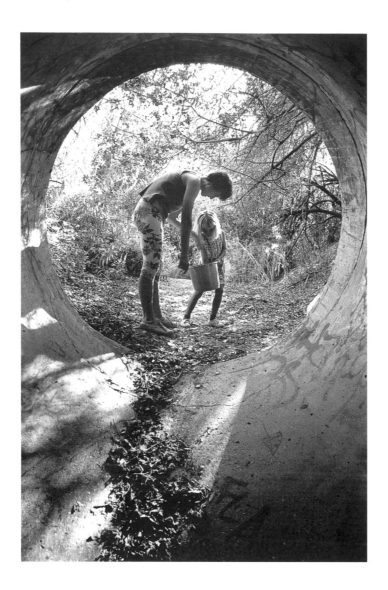

going on. Nobody explained things to me or held my hand through it. He just left, and it was never talked about. The divorce agreement said that we couldn't visit him, and since he wasn't allowed in our house, the only thing he could do was drop by and hang out with us in the neighborhood, so we never got to really reconnect with him. So, you see, it's important to me that Maddy and David have their own relationship, and to make that happen, I've had to put aside my own feelings of rejection and hurt about our marriage not working out and say to David, "Okay, I chose you; I still love you; it didn't work out, but I can forgive you and move on with you because we're going to be Maddy's parents forever."

It's not always easy because I still love David very much. But what helps me stay true is to remember Maddy, who is my number-one everything and who is going to be most impacted by our breakup. The last thing I wanted to do was to drive a wedge through their relationship. **So I had to wake myself up from this image of what I thought a loving family ought to look like** and make room for something new.

At first I was terrified of being divorced and being alone, but what I found was that as soon as I was able to release David, and let go of being hurt, and angry, and full of blame, I felt this incredible freedom and love for him that I didn't always feel in the marriage. I can hardly explain it but to say that when we were married, **I had so many expectations of him, and pictures of this long legendary marriage that we would have,** and I was very threatened by the idea of anything changing. But in letting go of him and forgiving myself, I've allowed the love that we always had for one another to reenter and be present in our lives. But I also work every day at letting that love in—which I didn't do when we were married.

Most importantly, Maddy feels our love when the three of us get together. She's absolutely delighted if the three of us spend a few minutes together when we're dropping her off at each other's places. David and I will find out what's going on in the other's life, and Maddy sits there drawing pictures or talking with us. She doesn't get to see us together very much, and she can get pretty giddy about it.

51

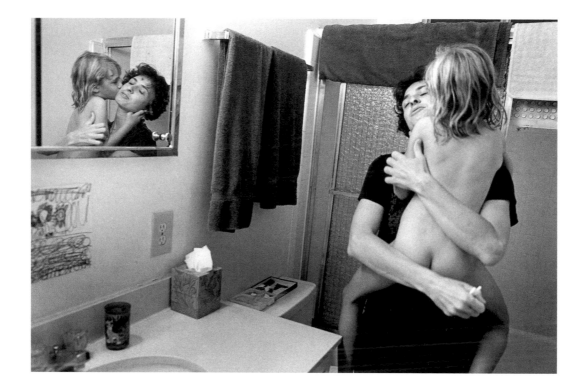

My own parents haven't been in the same room together since their divorce. But even now, if my mom says something halfway nice about my Dad, it feels so good. It validates me and it makes me feel loved by them, and I think that's how Maddy feels.

And she's fine. She's a great kid and is loved by both of her parents. Sometimes she talks about the divorce and will say, "Now, why did you guys get divorced?" But she doesn't really want an answer so much as **she just wants to talk about it.** At first, David and I tried to answer those questions, but Valerie said, "Don't focus on the people, focus on the marriage. Tell her that the marriage didn't work, and that it's not Daddy's or Mommy's fault." And that's really worked. Maddy doesn't feel like either one of us is blaming the other. And she doesn't feel bad when she's with one of us, but missing the other.

When we're together and she's thinking about David, I tell her to call him. And when she's with him and thinking of me, he might tell her to make a card for me. We even have a picture of David and Maddy up in our kitchen—which is something that most divorced parents couldn't handle because it's too painful. But David is her dad, and I want her to know that I acknowledge her relationship with him and that he loves and cares for her enough to make a nice picture of them and give me one, too.

The three of us actually went out to dinner for Maddy's birthday last week and had a great time. But then as Maddy was saying good-bye to David she got really sad, and then I started sobbing because I didn't want to say good-bye to him, either. As she and I were driving home we had to pull off the road because we were crying so hard. Part of me felt like we'd had such a good time together, why can't we just be a family again? But I know it's more complicated than that. I called David when we got home, and he said that he felt sad, too, and we agreed that we shouldn't get together like that again. It's not that we wouldn't want to, we just don't know how productive it is for Maddy.

You know, **being a parent is the ultimate growth experience, if you choose to grow.** Being a divorced parent is even more of a challenge—especially when you love your ex-husband, but it's grown me in ways I would never have gotten to had we stayed together.

53

DONNA ARMSTRONG

DONNA ELIZABETH FOOTE ARMSTRONG IS THE MOTHER OF SEVEN-WEEK-OLD TRIPLETS
HANNAH GRACE, EMILY NICOLE, AND BENJAMIN STEWART.
SHE IS THIRTY-EIGHT YEARS OLD AND LIVES IN A SMALL SOUTHERN TOWN NEAR NASHVILLE
WITH HER HUSBAND ALLEN, A COMPUTER CONSULTANT.
THEY HAVE BEEN MARRIED FOR SEVENTEEN YEARS.
BEFORE BECOMING A MOTHER, DONNA WAS
A SECRETARY FOR SIXTEEN YEARS.

Not being able to get pregnant really messes up your mind and does a real number to your self-esteem. You like to think of yourself as someone who's in control of your life, but then you come across something like this and it gets to you.

We tried to have a baby for almost five years, but we just couldn't get pregnant. We even messed around with this fertility doctor in Nashville for three years after that, but even he couldn't help us. Finally we came to the brilliant conclusion that trying to get pregnant was too stressful, so we decided to adopt.

We went through months of classes, we were inspected, and we spent thousands of dollars to get in this book that birth mothers look at. There were seven couples in our adoption group, and while everyone was pretty friendly, we were also real competitive because when one couple gets a baby you're happy for them, but you're sorry for yourself because you know that a birth mother saw your picture and passed you by.

We became good friends with this one couple in the group, Betsy and Tom. We'd get together with them for pity parties, bitch sessions where we'd say to each other, "Why them? What's wrong with us?" We'd go to movies together or go shopping—basically **trying to compensate for not having babies.** Underneath it all we were really torn up that other couples were getting babies before us, and I guess bitching about it and hanging out together made us feel better.

One time the four of us were in this restaurant in Nashville, and there was this couple from our group having a meeting with a birth mother. When they saw us, the husband immediately got up and came over and said, "We're meeting with the birth mother, please do not come to our table." Well, Betsy, she immediately had to get two rum and Cokes. It just tore her up royally. I mean, there was a birth mother sitting over there who'd seen our pictures, but who hadn't chosen us. When they got up to leave the restaurant they passed by our table, and I'll never forget, the wife had this long blonde hair and she swooshed her head really fast as she walked by, and a hank of hair flew past us. She didn't even look our way. **That was the pity party to end all pity parties.**

The following week Betsy and Tom got a baby. And as much as we loved them, we couldn't go around them for a while because we'd look at their baby and know that it could have been ours. Betsy is such a soft-hearted person, too, and I knew it was hard

55

for her to call and tell us, especially since she and Tom were the happiest they'd ever been. We just had to believe that their little girl wasn't meant to be ours.

Of course, the adoption people kept saying, "You'll be next. You'll be next." But we never were. We didn't know why. Was it the photo of ourselves that we put in the book? Was it something we wrote that people didn't like? Was it that we didn't make enough money? Every time someone passed over our page, we felt rejected. We were in that book for three years and only got one call.

I remember that day. Allen phoned me at work. "We've been chosen!" he said, and I shouted, "Yippie!" And then he said, "But the baby's mother is HIV positive." **I cannot remember ever being so excited and so crushed in the course of five seconds.** He spoke the words I'd been wanting to hear for three years, but then it was completely sad. It turned out that this nine-month-old boy had been abandoned by his mother and left with his grandmother. She claimed that the baby wasn't HIV positive, but he wasn't old enough to know conclusively whether he was or not.

Allen got over that part real quick, but I had to work at it. I'm not proud to say that, but you put so much emotion, so much time, not to mention money, into adopting, and it's hard to think about adopting a baby that might not live to be five years old. Finally we agreed to meet with the grandmother, who was real friendly and let us take the child over to Betsy and Tom's house so he could play with their baby. But when we took him back to the grandmother, she'd turned into a nutcase. She says to me,

"What makes you think you can be a mother to this baby? You _are_ going to be quitting work right away, aren't you?" Well, I flat told her no, that I was going to keep my secretarial job.

That's when she went wild and pulled out of the deal. Then she was back in. Then she was out. Then she was in again. Finally we said we weren't interested. It was a nightmare. She wanted to move to our town to show us how to take care of the baby, but we didn't especially want to adopt a grandmother who was going to be on our doorstep for the rest of our lives. The little boy was eventually adopted by somebody in California.

So now it had been eleven years since we first tried to have a baby. Five of trying on our own, three with the fertility doctor, and three trying to adopt. So I said, "Let's give those fertility treatments one more shot—" and bam! A month later I was pregnant.

You can imagine the shock.

During the first ultrasound the nurse says, "Oh, now, there's the fetus! Oh, my! There's another one! Oh! I believe you're going to have twins!" And I'm sitting there thinking, "Oh, God!"

And then there were three.

56

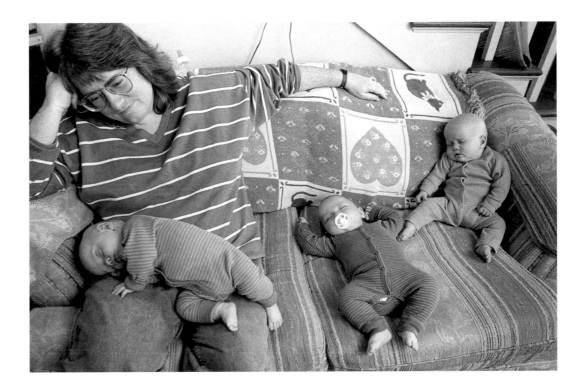

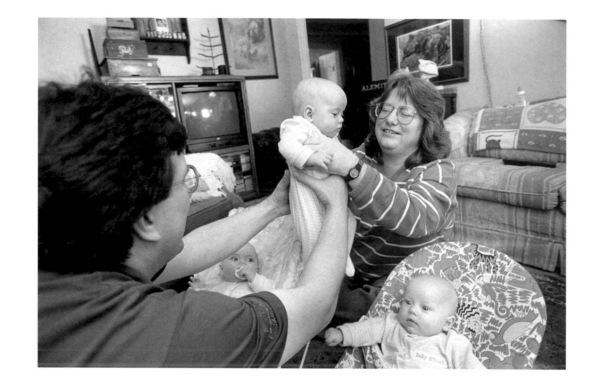

I said, "Please, tell me there aren't any more. Please stop at three."

I'll be honest with you, I wasn't real happy about it. Here I was, thirty-seven years old, first pregnancy. Nothing ever comes easy to me. It had to be something out of the ordinary.

Allen's mother said she thought it was the prayer that did it. She said, "Well, I prayed for you. I prayed twice in one day." And Allen said, "Momma, you're supposed to say amen in between those prayers! You're not supposed to pray for two and then three!"

But I agree with her, I do think it was God's doing. He said, You want children? You've been asking all these years, so here you go! He did it on *his* time schedule, for *his* reasons, not ours. That's why none of the earlier tries at fertility and adoption worked out for us. They were always telling us in the adoption process that when it was time, we would get the right baby. But that's hard to accept when you want a baby so bad and everyone else is getting one.

One thing I found real interesting when I was pregnant was that all these people that we didn't know were trying to get pregnant came out of the woodwork and wanted to hear how we did it. It just showed me that **you have no idea what people are going through, and while you may think that you're the only defective person out there, you're not.**

Now I feel defective in another way entirely because, well, **I never really saw myself as the maternal type, and here I am trying to take care of three babies.** These last seven weeks have been a total blur of feeding, burping, and changing diapers. I couldn't do it if it weren't for Allen—he's the only one with any common sense around here. I go to him when I can't get them to eat or when I can't get them to stop crying. I swear, sometimes it seems like they cry for no reason, and I'm wondering, "Why are they crying? What have I done?" Especially Ben. He'll just scream while we're trying to feed him. And I'll think, "This baby hates me!" Maybe it's because I don't feel like their mother yet. Maybe it's because there wasn't that instant bond with them that all these mothers talk about.

Many midnights I have sat on the sofa feeding one baby while the others are in their rockers screaming, and I sit here crying right along with them. I just lose my patience sometimes. Part of it, of course, is that we're not getting much sleep—which is a strain on me and definitely on Allen, who is one of these people who doesn't work well when he's tired. There are days when all we do is snap at each other and get real snooty. I'll say, "Don't you think you need to take a nap? Have you taken your blood pressure medicine? *No,* I didn't think so!" But I think we'll be okay. After all that we've been through to get these children, we can't let a little lack of sleep destroy our marriage.

59

MARY PUGH-DEAN

MARY PUGH-DEAN IS THE THIRTY-FOUR-YEAR-OLD MOTHER OF MIKA DEAN, WHO IS ONE YEAR OLD.
MARY HAS SPINA BIFIDA AND USES A WHEELCHAIR. HER HUSBAND STEVEN HAS
CEREBRAL PALSY AND WORKS IN REAL ESTATE. MARY WORKS AT
THE WORLD INSTITUTE ON DISABILITY AS A
HUMAN RESOURCE DIRECTOR.

I don't think it really hit me that I was a mother until about two months after Mika
was born. I'd never expected to carry her full-term because I'd already had three
miscarriages, and I kept saying to myself, "Any day, it could happen again." **I didn't even tell Steven
I was pregnant until I was five months along** because if I did miscarry,
I didn't want to have to deal with questions he might have about why I couldn't have a
baby and how I was feeling. I just wanted to work through it alone.

A lot of it had to do with me not feeling worthy enough to have a child. I've always
felt that I wasn't worth having things that were brand new or perfect, and something
inside me was saying, "Maybe this is not your plot in life. Maybe you don't deserve to
have a child." And if I did have a child, I felt that there would be something wrong
with it.

maybe you don't deserve to have a child

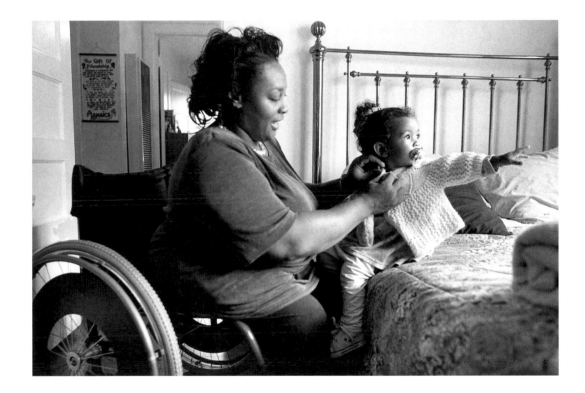

I definitely had some fears about passing my disability on to my baby—although there was only a 4 percent chance that would happen. I often prayed that if it wasn't meant to be, or if I were to pass my disability on, that God should just intervene and not let it happen because **spina bifida is difficult to live with, and I didn't want my baby to start off with all those odds against her.**

But early in the pregnancy I had a dream which helped me make peace with some of my concerns. In the dream, I'm standing in the doorway of my house and I'm staring at this very deformed baby. Then the baby looks up at me and says, "Mama," and I hold my arms out and say, "Come to me." I remember feeling a lot of love at that moment. I wasn't looking at the baby as though it was freakish. I was thinking, "Wow, that's different," but there was something drawing the baby into me that was so important. **The dream told me that whatever child I had would be my child, that I would love it, and that everything would be okay.**

And everything turned out fine. Mika is very healthy, and in a big way, she's taught me that I'm okay, too. A lot of people downplay stuff that disabled people do. They say, "Well, you got the job because of affirmative action or because of your disability, not because you qualify for the position." So it's been important for me to have people see Mika and see that I can be a mother. She's the first unadapted thing I've ever done. In my thinking, it's like "I played on your playing ground without any special rules or without any head starts, and Mika is just as good as any other child."

Because I'm in a wheelchair, I won't be able to take Mika to a lot of parties and functions. Not everything is accessible to me. But that doesn't mean I'm not a loving mother. Mika and I spend a lot of time communicating with each other. She's in my lap or we play on the floor or on the bed. We bring our favorite objects to wherever we are, and that's where we bond and have fun. Later on, she'll want to expand her world, and we do have some concerns because we'll want to expose her to a bigger world and I know I'm going to be severely hampered in that. So I've recruited what I call *tias,* aunties and friends whom I adopted early in the pregnancy and whom I gave basic job descriptions to, like "You're going to teach her how to ride the bicycle," and "You're going to take her on hikes," and "I need your legs and arms during this period."

in a big way, she's taught me that I'm okay, too.

She has an outdoor tia, and a tia who will take her traveling and give her cultural experiences. The tias have also empowered me during the times when I've panicked that I couldn't do everything for Mika. They've always encouraged me to see that it wouldn't be impossible for me to go hiking or traveling with her one day. They're helping me to change the way I see myself.

One of the ways I want to grow more as a mother is to be able to be more assertive when it comes to some of the things people say to me. They'll say, "Is that your daughter?" or "Is he the father?" It's as though they have a hard time admitting that Steven and I have a relationship much like theirs, and that we're intimate, and that we actually have the same privileges and desires for the American Dream as they do. Women will say, "Well, if you can have a baby, then I can definitely have one." My response depends on the day and the moment. Sometimes you can tell when people aren't trying to be malicious and are just speaking from their ignorance, so you excuse that, but sometimes I want to say, **"Why would I be any different from any other mother having a child?** Why is it that my situation would make it easier for you?"

People are always asking, "How do you do it?" But I don't think about it. It's like wearing glasses. It's just something that I do.

Four months after Mika was born, I was invited to speak on a panel with other disabled mothers and they asked us questions like "What's it like to be a disabled mother?" And I said, "I'm not a disabled mother. I'm just a mother." You see, Mika doesn't make that distinction. I'm just her mother, and **it doesn't matter how I get to her when she cries, it's just important that I get to her**. She doesn't see a wheelchair, and I don't think she knows that we get her into the house by wheeling her in with the stroller instead of carrying her in our arms. Other people make a big deal out of that, which makes it difficult just to be ourselves. They make too much of a problem out of our disability, and they miss out on us being human. But Mika hasn't devalued me because of my physical inabilities. And that's the most special thing about being a mother.

ANNIE FIERY BARROWS IS THE THIRTY-FOUR-YEAR-OLD MOTHER OF SIX-WEEK-OLD CLIO
FIERY GOLDSTEIN. ANNIE IS A WRITER AND EDITOR WHO LIVES
WITH HER HUSBAND, JEFFREY, A SCHOOLTEACHER.

ANNIE FIERY BARROWS

For starters, it was my husband Jeffrey who really wanted to have a kid. I'd known ever since about fifteen minutes after I met him that he was supposed to be a father. He's great with kids—and I don't mean he just pats them on the head, has fun with them, and then leaves. His entire personality is about commitment, and he's got joie de vivre up one side and down the other.

But me, well, I've always felt really distant from children: I've never understood them. I hated being a kid. I didn't like playing, and I didn't like other children. I wanted to hang out with grown-ups or be left alone. My pleasures were—and still are— the pleasures of adulthood, words and ideas and scholarly stuff, the things you do when you're alone. So why would I put somebody else in the position of being a kid? And even worse, **what if I had a kid who wanted me to actually play with it, or who wanted to join a soccer team and make me come out and watch?** What the hell was I supposed to do then?

But Jeffrey was persistent. He said we had to do it because if we didn't have children we'd be stuck as a couple. It's not that we needed to make up for something in the relationship, but that without children we wouldn't grow because we would continue to make ourselves the center of the world, and in my case, that meant becoming more of the antichildhood, antiplayful, ultra-controlled, and ultra-mannered person that I was. Jeffrey's point was that the mess of life, the chaos, the challenges and the growth that comes from having children is what life is about and is much more important than my sense of control and productivity. And, as much as I resisted it, I agreed with him.

But that didn't mean I had to like it. A lot of things bothered me. The pregnancy books just enraged me because they were all about the entire sublimation of my personality into being a mother. You know: Lose yourself. Lose your life. Eat whole wheat. Drink orange juice. Don't drink, and, ultimately, don't enjoy yourself because you're a mother now and your life is over. That book *What to Expect When You're Expecting* made me crazy! Insane! It's not a handbook for being pregnant, it's a handbook for obliterating your character! Start with the cover—that neutral picture of a woman wearing nondescript clothing sitting there looking at a nondescript plant against a nondescript background. She's got this bland look on her face, like she's thinking about wheat germ. She doesn't have a self or any idiosyncrasies. She's not humorous,

65

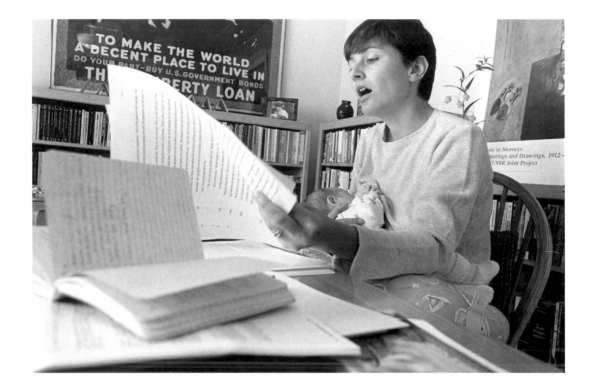

not bitter, she has no past—all she has is motherhood. Okay, maybe I'm projecting a little bit here, but if it were me in that picture, I'd be shaking my fist!

Pregnancy wasn't the problem, that was fine—I didn't barf, I felt great—but I was pissed off! People kept saying, "Oh, you look so great! Isn't this fun! What a beautiful time in your life! You're going to be such a great mom! Aren't you feeling maternal?" And I was saying, "Nope, uh-uh, not feeling maternal at all." I mean, I might have been, but I felt so angry about the image of the calm, peaceful, blissed-out mother that people seemed to want me to take on. I wanted to dye my hair green or pierce a part of my body. I wanted to have an edge and shake things up. But people don't want pregnant women to be mean or funny or bitter or cynical or say the word *fuck*. They don't mind them being scared because then they can comfort them, but generally, **people wanted me to be nice.** I mean, I'm nice enough, but that's not my overwhelming characteristic.

So I'd say things during my pregnancy to subvert everyone's mother paradigm, like I'd call my baby the little parasite or the little sycophant. I'd say, "She's just like mistletoe on a pine tree, sucking the life out of me—she's a little vampire!" People were taken aback, but I thought I was just being honest and funny. And it wasn't that I was so bitter toward my baby. I didn't want to hate my kid, I wanted to love it.

Of course, the big surprise for me was that I did.

About two seconds after Clio was born, I felt the exact rush of love that people kept telling me I would. I had figured that was one more thing that everyone was going to be wrong about—you know, everybody always said I'd love Disneyland and I hated it. But I looked at her and couldn't believe how beautiful she was. Her eyes were wide open, her lips were red like roses, and her skin was lovely and pale. Later, after I'd come out of my morphine trance—(I had an emergency caesarean because she had the umbilical cord wrapped around her neck five times—I love that about her—she is such a wild woman)— I woke up and thought, "Well, that love-fest probably didn't happen." But when they wheeled me into the recovery room, there she was again, and it was like **"Aggg! This baby! Let me hold her! Let me have her!"** It was such a shock to me.

67

The next day I called my mom and said, "Be honest, is she the most beautiful baby you've ever seen or am I crazy?" And she said "Well, you're a little crazy probably." I'd always thought that I'd be so filled with mind, because that's how I am. I knew I'd be able to keep a baby alive and eventually love it, but I figured that Jeffrey would be the love ball, and I would always be the slightly removed one, never really having the right responses and being much too cerebral.

But there are times when I'm so totally overwhelmed with love for Clio that I spend hours just looking at her. If someone had told me four months ago that I would spend half an hour waving my kid's legs around on the changing table, I would have said, "What the hell? Half an hour? I don't have a half an hour to wave my kid's legs on the changing table!" But the thing is, I do, because that's what makes Clio happy and I want her to be happy.

It's totally irrational, and I'm not used to being totally irrational.

Don't get me wrong. I'm still impelled by impatience and crankiness, but I've softened some. Last night we were watching the movie *Fargo*, and I was holding Clio in my arms. Well, there's Steve Buscemi getting mangled by the wood chipper, and I thought, "Clio shouldn't be in the same room with this kind of mutilation." So I quickly ran out of the room. That's new. **I've also stopped yelling at people out of the car window, which was something that I did all the time and which gave me a great deal of pleasure.**

I'm embarrassed to say this, but I guess I have felt a kind of rip-tide pull to even things out, to become more placid, and it's an odd thing to see in myself. I don't know how much it will ultimately pull me. I don't want to lose my intellect or my sharpness and end up staring at nondescript plants against nondescript backgrounds, but at the same time, I don't want to have so much edge around Clio.

Luckily, people haven't really commented on my softening or gloated that they were right. I think they're afraid that I'd deck them. But Jeffrey has been surprised because he was really listening to me all those years when I said, "I'll have a baby, but I'm going to hate it and you're going to take full responsibility, and if I have to leave suddenly to go to France, you have to take care of the kid because this was all your idea!" So I think it's been somewhat of a relief for him to see how all of a sudden I love Clio.

68

I mean, we're in the vegetable stage.

Of course there are times when I'm just an old, sick animal. It's 3:30 in the morning, the kid has passed out after having only one boob, and I'm exhausted but I'm pumping away, and my hair is greasy and I have spit up on my neck and I can hear Jeffrey snoring in the next room and I want to kill him. I mean, we're in the vegetable stage. Not a lot of dessert going on around here. We're eating our brussels sprouts. We're getting up in the middle of the night, and it's not so hot. But I think this breakdown of control is important for me. To be a family, we needed to break apart the perfectly vacuumed rug and the stacks of canned artichoke hearts just in case we want artichoke hearts for something. That is not what we need. We need the mess of the baby crying, and we need the mess of Jeffrey and I negotiating our time, and I need the anxiety and the love and the muck of it because I believe that my life was inauthentic before, in some way. It was too controlled, too contrived, and that's not truth for me. Sure, there were tons of rewards, but I was too keyed in to those rewards. **And if you only ever do things that you like and that you're good at, you're not courageous.** Being a mother is more courageous and so much harder than writing or working or being a good partner. It's harder than everything else I've ever done by about twenty times. Partly because I'm not getting anything back. I'm not getting an A or a gold star. All I've got to show for myself at the end of the day is a bunch of dirty diapers and maybe some laundry done.

On the other hand, when it's good, it's never been so good. Last week we were having dinner together and Clio was being an angel, and she and Jeffrey and I were dancing to Chet Baker and she was looking around with these big starry eyes and Jeffrey and I were goggling down at her, madly in love. It doesn't get much better than that. We're a family now, and that's really good.

69

CHRISTY CORBITT

CHRISTY CORBITT IS A NINETEEN-YEAR-OLD SINGLE MOM WHO LIVES WITH HER
TWO-YEAR-OLD SON GABRIEL IN A SMALL APARTMENT.
SHE RECENTLY GOT HER HIGH SCHOOL DEGREE AND HAS DREAMS
OF BECOMING AN ARTIST.

My life? If you were nineteen years old, I don't think you would like my life very much. I only get $490 a month, and my rent is $250. In the beginning, I wasn't getting food stamps, so I tried to keep myself from eating so Gabriel would have enough. But by the end of the month I was always starving. You've got to be a hustler if you don't have a lot of money. I can't buy nice clothes for myself, and I can't dress Gabriel up as much as I want to. I'd like to take him to see *James and the Giant Peach,* but I can't because I only have $80 dollars left for the whole month, and there's three weeks left to go, so I have to budget. At least now I have food stamps.

I don't think you would like my life very much

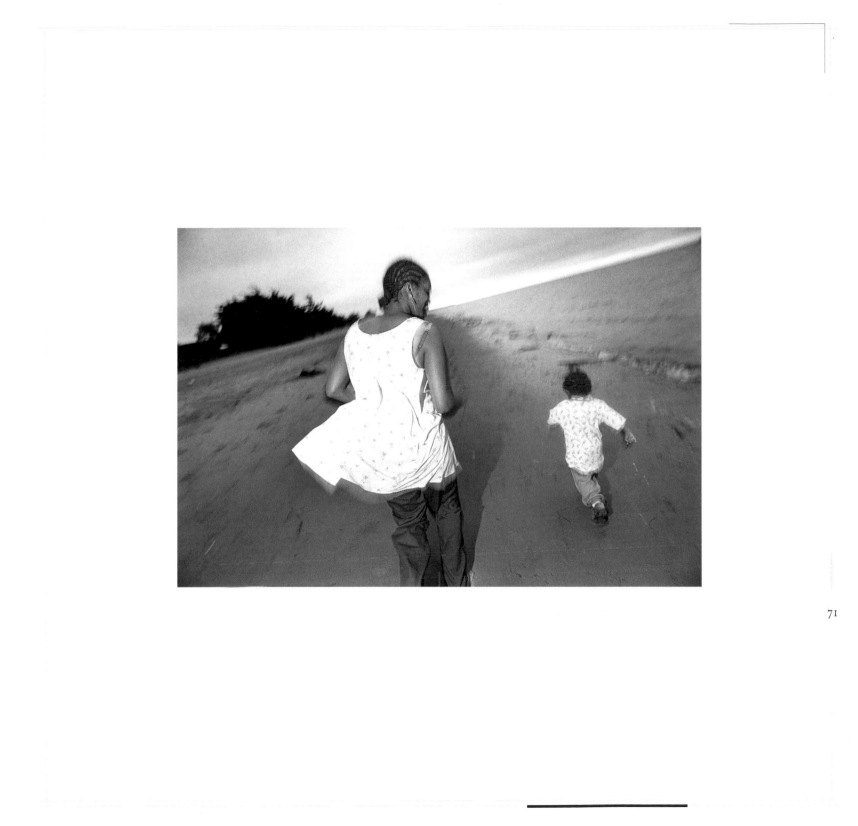

I was seventeen when I had Gabriel. Me and his dad, Noah, got together five months before we got pregnant. We argued a lot, but we loved each other tremendously. The night we conceived Gabriel, we just said, "Forget it—we're not going to try and restrain ourselves by pulling out and stuff like that." We said, "He's gonna be our love child." We were calling him Moonbeam because me and him were like hippies.

But then Noah wasn't happy when I told him I really was pregnant. We started arguing a lot, and it went downhill big time. He was scared of the responsibility—I mean, he wasn't responsible in the first place, but I didn't see that because I was really wanting a baby. I was depressed because my mom and sisters and me had to move to a new part of town that I hated, and I thought having a baby would make me feel better.

Then Noah started cheating on me and told me that he didn't want the baby and that I should get an abortion and not ruin his life. And I'm thinking to myself, "Hey, what about love child?" And even though I'm a Christian, I did think about an abortion. I also thought about suicide. It was a really depressing time for me because I was living in my mom's house, and her boyfriend used to smoke and walk around the house naked, and I didn't like that kind of stuff because it disrespected my house. He'd call my sisters and my mom fat, and one day I said to him, "Why do you make people feel so low? This house wasn't like this before you came here. Don't do this stuff!" Then he slapped me and we got into a fight and I ran away. I was about eight months pregnant, and I went up to a halfway house in the hills. Later we got counseling and I went back home, but it was pretty much the same as it was when I left.

I prayed to God a lot, and that's what got me through. And I asked him, I said, **"God, I don't know if I'm worthy enough, but can I have one of your angels?"** And then some really strange things happened to me that were like signs telling me to keep the baby. One time me and my friends were on the bus, and this guy gets on with a pail and he comes up to me and says, "How many months are you?" And I said, "Five months." And he said, **"Don't get rid of that baby. Don't give up. You're going to be a really strong mother."** And my friends looked at me like "What in the world? How did he know anything?" He was this bum guy just coming back from fishing, and he's telling me not to give up. I definitely thought that was a message from God, 'cause how else could he have known how hard things were for me?

It's been two years since I had Gabriel, and being a mom has its ups and downs. The beginning was definitely the hardest for me because I was still so depressed about being alone with him all the time, and there were times when I would just leave him by himself. One time I left him behind and started drinking coolers with my friend. We got kind of drunk, and she got me in these tight clothes and we went out on the street. I remember this guy stopped and said, "Well, hello ladies." And then he looked right at me and said, "You are so beautiful." And I said "Thanks," but I was thinking, "This old man is trying to get some." And then he starts staring at me and he says, "When the sun shines through your heart I can see all the goodness and all the love that you have for people. Somebody is at your home right now, and you're really a good mother to that person." And silently, in my mind, I asked him, "Are you an angel?" And out loud he answered, "Maybe."

After that I took a grip of myself and I started changing. If I wouldn't have changed, I probably would have become irresponsible because sometimes when I get free time, where I can be like a child, I feel like I'll fall in a hole and never find my way out. I'd probably leave Gabriel behind and forget about him.

But you know, I like the responsibility of being a mother. Gabriel is with me all the time, and since I don't drink, or smoke, or do drugs and party anymore, I'm mostly just at home with him.

He keeps me disciplined and responsible, and he helps me feel like I have more of something. I had horrible self-esteem before I was pregnant. Everybody always gave me compliments and thought I was pretty and sexy, but I never felt very good about myself. Ever since I was five years old I'd been molested by my mom's boyfriend, my girl cousin, my guy cousin, and my mom's friends. They were all about thirty years old, and **I think they took advantage of me because I was quiet and scared to talk to my mom.** I felt like it was my fault and that if I told her, then she wouldn't like me as much and think I was bad.

But after I had my son I had better self-esteem. People are always coming up to me and saying, "That boy is so cute! He is so beautiful. He looks just like you!" And I say "Thanks. If I look like him then I must be beautiful." I'm proud of him big time, but I don't spoil him. I'm stern with him because I want him to know that we have a hard life and he just can't think everything is great for him.

Everything is going to work out though. **That boy keeps me strong.**

I think he is one of God's angels.

73

LISA ANN MAXWELL

LISA ANN MAXWELL IS A FORTY-TWO-YEAR-OLD COMMUNICATIONS SATELLITE ENGINEER AND THE PARENT OF TOMMY MAXWELL, WHO IS FOUR YEARS OLD. BORN MALE, LISA IS TOMMY'S BIOLOGICAL FATHER, THOUGH TODAY SHE LIVES AS A PRE-OPERATIVE TRANSSEXUAL. DIVORCED FROM TOMMY'S MOTHER, LISA SHARES CUSTODY OF TOMMY WITH HER EX-WIFE.

I've wanted to be a woman ever since I was six years old. When I was a young boy, I liked playing with dolls and wearing my mom's bikinis. And when the other boys were playing sports and trying to figure out how to get girls, I was experimenting with makeup and hairstyles.

I guess I'd been in denial about who I really was until four years ago. I'd always lived as a man who privately dressed in women's clothing, but I never thought I've have the courage to do what I'm doing now, which is to physically become and live full-time as a woman. This is a very big change for me, but I just couldn't live as that other person anymore.

When I first came out, I thought I was a transvestite, but I soon realized that I had nothing in common with transvestites and everything in common with transsexuals. A transvestite is happy being a man or a woman, a transsexual is not. My organ disgusts me. I find it abhorrent and I'm actually embarrassed by it. With transvestites, there's more of a sexual component. They have large panty hose and petticoat collections, but I've never gotten into that. It's more of an identity thing with me, it's how my brain works and not so much about sex.

When I came out as a transsexual, my parents were surprised because they thought I'd gotten over it. By the time I was ten years old, they'd pretty much figured out what was going on and had sent me to a bunch of psychiatrists because they thought I was a homosexual—which I guess I am. **All I know is that I'm very queer. I'm about as queer as you can get** because I've been a heterosexual man, a heterosexual woman, a homosexual man, and a homosexual woman.

Now I'm a bisexual woman and pre-operative. I'm taking hormone treatments which do all sorts of wonderful things like make my skin softer and fill out my figure. They've also enabled me to grow breasts and they've made my organ smaller, which is good. I'm scheduled for my sexual reassignment surgery next year.

Six years ago, I married a woman who I thought tolerated my fem-centered side. I was very honest about who I was, and she was very accepting of me and even bought me dresses. But after Tommy was born, I met my first transsexual and realized that I wasn't someone who liked to dress in women's clothes occasionally, but in fact I wanted to *be*

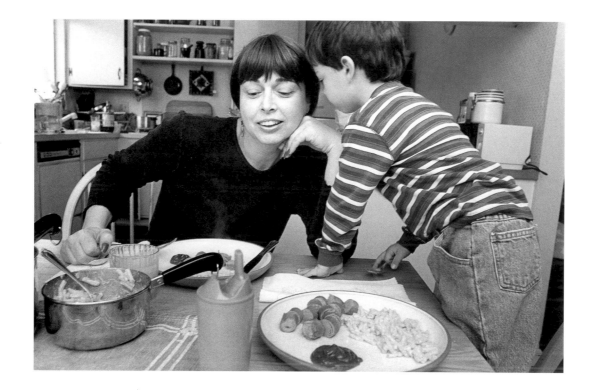

a woman. Shortly thereafter, my ex decided that we should get a divorce. That was over two years ago, and as much as I loved her and didn't want to break up, what crushed me even more was to live apart from Tommy.

I love Tommy like you wouldn't believe. I equate being Tommy's parent with living or dying. I couldn't imagine living without him. He brings a richness to my life, an unconditional love that I don't find in other relationships. If it came down to my life or his, there would be no question that I would run into the street and push him away from the truck and kill myself.

I've definitely been concerned about how my changes will affect him. In some ways he would rather have had a daddy, and **he's told me that he doesn't want me to change anymore. I think he's afraid he may lose me.**

When I told him that I was changing my name from Michael to Lisa, he said,"Daddy, Lisa is a girl's name." And I said, "I know, Tommy, but I like that name." Then he asked me why I was doing it, and I said because I was changing my sex, and he said, "Okay."

I heard him tell his friends, Jaime and Taylor, that **sometimes he calls his daddy "Mommy,"** and isn't that funny? But Jaime and Taylor always assumed that I was a woman, so it wasn't weird to them that he called me Mommy. What was weird to them was when Tommy called me Daddy. So I had to explain to them that I used to be a boy, and now I'm a girl. Then they started wondering if they had to change their sex, too. That's something that Tommy has wondered about as well.

A child psychologist I spoke with suggested I use transformative types of fairy tales with him, like *Beauty and the Beast* and *The Prince and the Frog*, because children understand transformation because their own bodies are changing at a bewildering rate. The key in these transformative tales is that, in both stories, the changelings were unhappy in their original state. The prince was very unhappy when he was in the castle, so he changed into a beast so he could deal with his own internal demons. It was only when he was able to deal with them and find love in his heart that he could become a prince again. And the frog was not very happy being a frog and had to find love to become a prince. I guess **I'm changing into the princess, and it's my own love and acceptance that will set me free.**

77

There have been a lot of changes, partly due to the hormones. **When I was Tommy's dad, we'd rent dump trucks and move rocks around in the yard.** Sometimes we'd go fishing or to the museum, or we'd play some sports. I was his entertainment director and much more interested in showing him a good time.

Now we do more creative things, like drawing and painting and making things out of clay. Tommy loves houses. He loves furniture, cookware, and those little plastic fried eggs and sausages that come with the little cooking set. He likes having tea parties, and I encourage him because I think it's important that he doesn't just play with boy toys. Sometimes we'll even integrate the dollhouse with his Thomas the Tank Engine train set. Thomas the Tank Engine will come by and pick up Tommy, me, and my ex—we're the figures in the dollhouse—and we all go on a little adventure.

Tommy picked all our characters out. I'm the redheaded woman figure, he's the brownheaded boy figure, and my ex is the brunette girl figure. When he picked the redhead for me, I thought, "He's got it right. He knows what's going on here." I felt wonderful, as though he'd accepted me—which was one of my fears. But the dollhouse isn't so much about Tommy dealing with my transition as much as it helps him deal with the separation of his mom and me. He wants to put the family back together and it's been hard on him.

Since my transformation, **I worry about him more than I used to. It's definitely the hormones.** I'm more concerned about whether he's eating enough or if he's not feeling well. And I'm a lot more in tune with where he is emotionally. When I was his dad, I wasn't as in tune with that aspect of him, but I wasn't in tune with that aspect of myself, either. I realized that I had emotions, but it was like looking at them through a plate glass window and never being able to touch and be with them.

Now I'm a very emotional person. I cried for an hour last night because I was feeling sad. Tommy had been sick and so had my mother, and my partner and I were going through some rough times. I just needed time to cry, and I loved it because I felt so much better afterwards.

78

my ex is the brunette girl figure

When I was Michael, I might have dealt with those feelings by having some beer or escaping into television. But now if I feel bad, I try to talk about it. I spent years lying about myself, even to Tommy, and I won't do that anymore. I wasn't honest with him about who I was. I hid my women's clothing from him and it was very uncomfortable. Kids are smart; they know you and they know the soul of your being. If I'm feeling blue, Tommy will come in and hug me. We spend a lot of time kissing and hugging, things that daddies don't do as much with their kids. And he knows where my breasts are and he'll nestle into them the way he would with his mom.

I'd love for Tommy to consider me his mommy, but he already has a mom, and I don't think my ex would appreciate it if I called myself his mom because she might feel that I was trying to usurp her role.

So Tommy calls me Daddy or Lisa. I'm trying to get him to call me Lisa-Daddy, but it's only been nine months since my transition. I understand. It can be embarrassing when we're in public, or when I'm with other mommies and they'll say, "Isn't that funny, he calls you Dad." And I say, "Yeah, sometimes he calls me Dad and sometimes he calls me Mom." It's okay though. We'll take the time we need with this. Maybe one day I'll even be in a mother's group, but I feel like I need to work more with Tommy before I can do that.

For the most part, it's worked out well. Tommy accepts me as I am. He says that as long as I don't change anymore, he's going to be fine. He doesn't know that I'm pre-operative, and I don't think he needs to know that. I'm working with him very slowly on it. I want him to enjoy his childhood. I don't think he should have to deal with all my stuff, because it's too much for a little boy to comprehend. **What he needs to know about me is that I will love him forever, and he'll always have a place in my home.**

Tommy always says, "When I grow up, I want to be just like you, Daddy," and I have consistently told him, "Tommy, you need to be just like yourself." **If there's anything I can teach this child, it's to be who he really is and have the courage to be himself.**

That's the thing I think he'll learn from me.

79

HEIDI NARUM HYATT IS THE FORTY-YEAR-OLD MOTHER OF TAYLOR NARUM HYATT, WHO IS SIX, AND ROSE EVELYN HYATT, WHO IS ONE. HEIDI IS AN ARTIST AND RUNS HER STAINED GLASS BUSINESS FROM A COTTAGE IN THE BACKYARD. IN MAY 1996, SHE LOST HER HUSBAND, COUNTRY MUSIC SINGER WALTER HYATT, IN A PLANE CRASH.

80

Well, the first thing you need to know about me is that I'm a Texan. For some reason Texans need to tell people that right off the top. I guess we're kind of honest, straight-talking folks. **We like to tell it like it is.**

My husband Walter died this summer. It's only been a few months now, so I can't tell you how much it impacts me as a mother, but mothering is sort of a woman's job anyway, like it or not. You can say everything you want about being liberated and equal, that's a nice concept, but in reality, you follow these roles. Men want you to do what their mothers did, whether you want to or not, and frankly, women just tend to know what to do when it comes to children. Walter took care of things, but he was a musician and

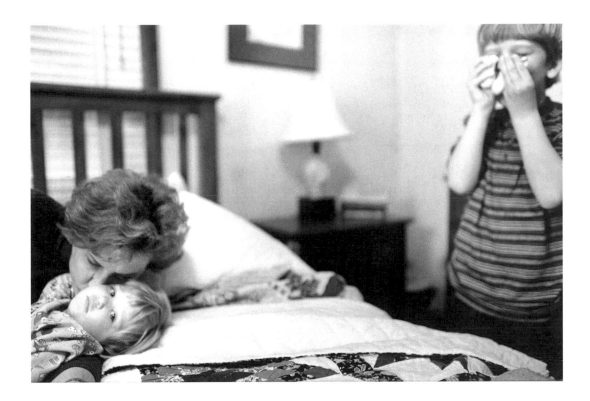

was on the road and gone a lot at night. He helped when he was here, but the major amount of thinking about things fell on my shoulders, so none of that has changed since his death.

My kids just don't have their dad to go to and spend time with. And of course they won't get to know him.

It's a big loss for us, but I wouldn't say that my world came crashing down. Walter and I had a very loose lifestyle. We were the kind of people who had friends in and out of here all the time and people stopping by for dinner regularly. We weren't into rules— Everybody gets up at this time and then we have breakfast at this time or We only allow this much TV or You have to do your homework at this time. I'd love it if I was that kind of person, but I'm not.

We were just kind of rough-and-ready folks. Life was loose and light, and fairly chaotic, but that's the artist's mind; you've got to see everything in 360 degrees. It's not a linear life, it's all-encompassing; it's moving and you've got to move with it. You throw kids into that mix and, well, I know they could probably use stability and I know they say that that makes better achievers or better-what-have-yous, but my own parents were loose like this and that's what I saw growing up. I'd go to the homes of other people whose mothers got up in the morning and they had orange juice and eggs and it was all nice like that, but at our house we got up and had Instant Breakfast and didn't even see my parents until six in the evening because they were artists and lived like artists.

Our life is similar. Since Walter died I've had so many people around and so much support that it's sort of like life as it was, except that he isn't here. In some ways, I have more support than I've ever had because when there's a mother and a father, the way our society is, **everybody just leaves you to it and lets you manage on your own**.

I know everyone around me worries that I should be breaking down right about now, and that I should get myself some counseling, but I'm handling this my way. I don't know if it's a survival thing, but I sort of just stay above it all the time. I don't look at life and say, "I need this much time for myself." My husband and I never said, "Let's get a sitter tonight and go to the movies"—you know, all the things they tell you to do in the ladies' magazines about how to create time for love and that kind of

I never thought about whether I had needs or not

stuff. We just plodded through every day and tried to get somewhere. We loved each other, but we didn't work on our relationship; we didn't work on keeping ourselves separate from our kid's needs. It's only been since Walter died that I've gotten some perspective on anything resembling *my* needs. It'll be times when I get ragged out and say, "I just want a little time with some adults! I want to think my own thoughts!" So when Walter died, I wasn't thinking, "Now *my* husband is gone, now *my* world has changed. Where's *my* life? Where's *my* time to myself?" I am whatever is taking up my time, and I never thought about whether I *had* needs or not.

People probably say I'm too even-keeled and that I've got a lot of problems because of it, but my approach is that I don't understand life. I don't know what's important. **The plane crash made me throw my hands up even more. I mean, nobody can give you any proof about why we're here and why we die.**

Walter had talked to Taylor a lot about death and what happens when you die. He wasn't afraid of these subjects with Taylor. He didn't say, "Well, we'll worry about that later, Son." My husband was a pretty different kind of guy. He was a heavy thinker, and I had the sense that the subject of death was something that they'd worked out together.

So I told my son that his dad died in the plane wreck, and Taylor said that he wishes that he hadn't, that he wishes he'd just been hurt and was all right. In school the kids had to draw pictures of their families, and **Taylor said that he was going to draw his dad as a ghost now.** So he's resolving it, making a place for it in his mind.

I tell him that I don't understand anything and that I don't know what life or death is about. I say, "I wish I could give you an answer, Taylor, and I wish I could change it, but I can't."

I've done a little screaming and crying about it, but it's kind of rare. I have to really work at it, and I don't want to put anyone else through it. Taylor knows I'm kind of stoic and that I don't tend to show it. But he'll see me looking kind of far away and he'll say, "Are you thinking about Dad?" And I'll say, "Yeah." Some nights he'll say, "Let's talk about Dad tonight," and I'll start crying and say, "I don't know, Taylor, it's just too hard to think about Dad for me," or maybe we'll get into it and cry a little bit together.

83

But sometimes when he's hounding me with "I want to go to Discovery Zone! Buy me a video game! I want to see this friend! I want to see that friend!" I say, "*I* want to see a friend! *I* want someone fun to play with! I don't have *my* friend anymore!" And he understands that. He gets that I'm a person, too. And **I guess that's new for me, realizing that I have my own needs.** Walter and I just did our thing, we didn't think of ourselves as parents, or people with certain needs, but in hindsight, we didn't take a lot of extra time to be together, either, and now I sort of wish we had.

I don't really know what our life is like right now. **It's only been a few months since Walter's death, so we're free-falling.** My ideas about what we're going to do next change every two weeks. Maybe we'll move to Texas, or to the country, or start a big business, or maybe we'll go to Australia, I don't really know. I was never one to think about the future much. I'm kind of a figure-it-out-when-I-get-there kind of person.

The new thing I've been questioning is what brings me happiness, because I was just living my life and accepting the way it was. Walter and I never wondered if we were happy. But his death has made me realize that you don't always have a whole life in front of you, and maybe there are some things that you have to go after now and not postpone for that uncertain future. Maybe I do want to see the Louvre in Paris someday. **Maybe I should have had more nights out with my husband.**

Maybe I do have some needs of my own.

84

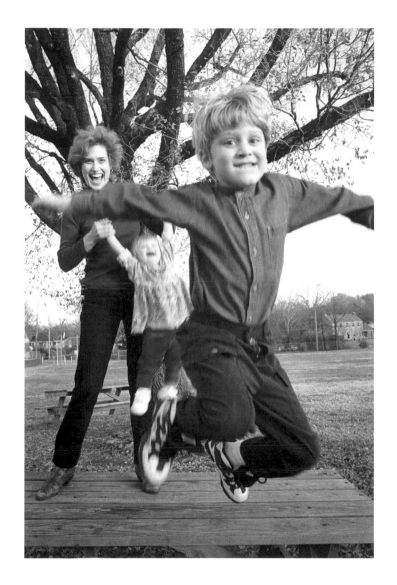

DEBORAH OROPALLO

Motherhood triggers my childhood memories.

The other day I was leaning over the sink washing Leo's hands and I remembered
my grandmother doing the same thing with me. I remembered the feeling of her
pulling my hands through the water with the big, fat bar of yellow soap. A few nights
later, I was carrying Leo out of the car as he slept and I remembered being slung over
my father's shoulder and how safe and good it felt knowing that he would carry me all
the way to my bed.

These are the kinds of memories and images that stay with me as I paint. I'm inspired by children's imagery—pennies, and flash cards, and the kinds of things that teachers used to put up on elementary school bulletin boards.

But the paintings go beyond these simple images. For instance, the penny paintings came from a children's lesson book on how to count money, but for me they played into a certain kind of fear. The week I painted them, my father-in-law had sent me an article saying that children under three die mostly by choking on coins. So suddenly every time I saw a penny on the floor, it meant something different to me than it did before. No one else is going to notice the penny on the floor and pick it up, but for me it became like a panic. **The paintings are full of things like hot irons and buckets of water— simple but potentially deadly things that are a fear for all mothers of young children.**

Right now I'm working on this painting about model railroad tracks because we live a block away from the train and we hear it go by all the time. As a kid I remember being mesmerized by the tracks. I loved the infinity of them, the feeling that they went on forever and that I could walk all the way from New York to California on them. But now when I hear the train go by, I fear for Leo.

It started innocently enough. I'd seen the toy tracks at Toys R Us as I was heading toward the diaper aisle, so I tossed them in my cart. It was only later, after I got home and began assembling them, that I started remembering what the trains meant to me and how I'd always wondered if putting pennies on the tracks would derail the trains. Just then the train down the street from our house went by, and I looked up and Leo looked up and I thought, "Uh-oh." I just don't want him to become fixated by them. I mean, he could wander down there one day.

The more I look at the objects from my childhood, the more I see in them and the more I realize how complex my feelings about them have become.

At the same time, I like this new direction that my painting has taken. Experiencing these more complicated feelings has inspired my work, which makes sense because having a child is such an exhilarating shift, and whatever makes your life richer is going to make your work richer, too.

At first I wasn't sure how becoming a mother and continuing to be an artist would work for me. Specifically, I wasn't sure how I'd be able to get into the studio. I also didn't know if I wanted knowledge of my private life, that I was a mother, to become

public knowledge, because I had a fear that female artists are taken less seriously when they have children. A gallery looking at my work, for instance, might not want to take me on if they thought I was going to have a family because they might assume that I wasn't going to be productive.

I remember seeing an interview years ago with Katherine Hepburn. She said that you can't have both career and family—that it has to be one or the other. And that touched a nerve in me because, **while I wanted children, there was no way I was going to stop making art.** So for many years I searched for role models, women artists who seemed to be making it in their careers and who also had children. I remember reading a story in the *New York Times* ten years ago about the artist Susan Rothenberg and reading the line, "She has a twelve-year-old daughter." And I paid attention to that because you didn't see that very often, at least not in the art world.

You'll see a spread in *Vogue* magazine with someone like Julian Schnabel, who is a very big painter in New York and who has five children with two different wives. He's been in so many articles with those children, with the twins on the kitchen floor or the other kids hanging off the drapes in the studio, and it comes across as a very romantic thing, you know, like he's got this great life and this beautiful wife. But you would never see an article about a woman artist and her children in the studio because there would be an assumption that she wouldn't be a serious painter if she were somebody's mother because, as everyone knows, mothering is a full-time thing and certainly not very romantic. A lot of women artists have kept their family lives very hush-hush for this reason.

But then I remember being at a Talking Heads concert and seeing Tina Weymouth pregnant and playing the guitar and I thought, "Okay, she's doing it." And then I saw the singer Nina Hagen during one of her concert intermissions pushing a Day-Glo baby stroller with a kid inside who had green hair, and I'm thinking, **"There are unconventional mothers out there who have these other lives." That was really important for me to see, and I guess I'm one of them now.**

like he's got this great life and this beautiful wife

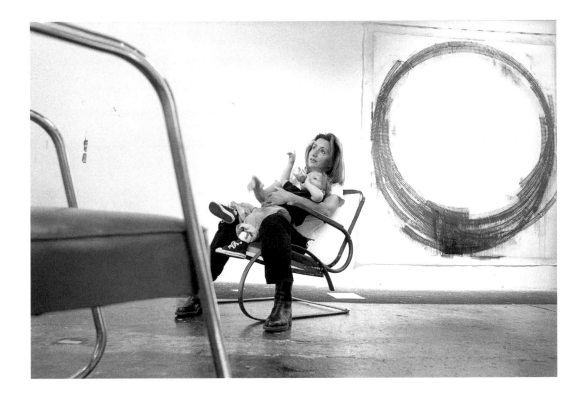

ANA DAMARIS JUAREZ

NICARAGUAN-BORN ANA DAMARIS JUAREZ IS THE SINGLE, TWENTY-YEAR-OLD MOTHER OF TWO-AND-A-HALF-YEAR-OLD JOSEPH DANIEL ZAVALA JUAREZ.

SHE ATTENDS A JUNIOR COLLEGE AND IS INTERESTED IN BECOMING A REPORTER OR A RADIO DISC JOCKEY.

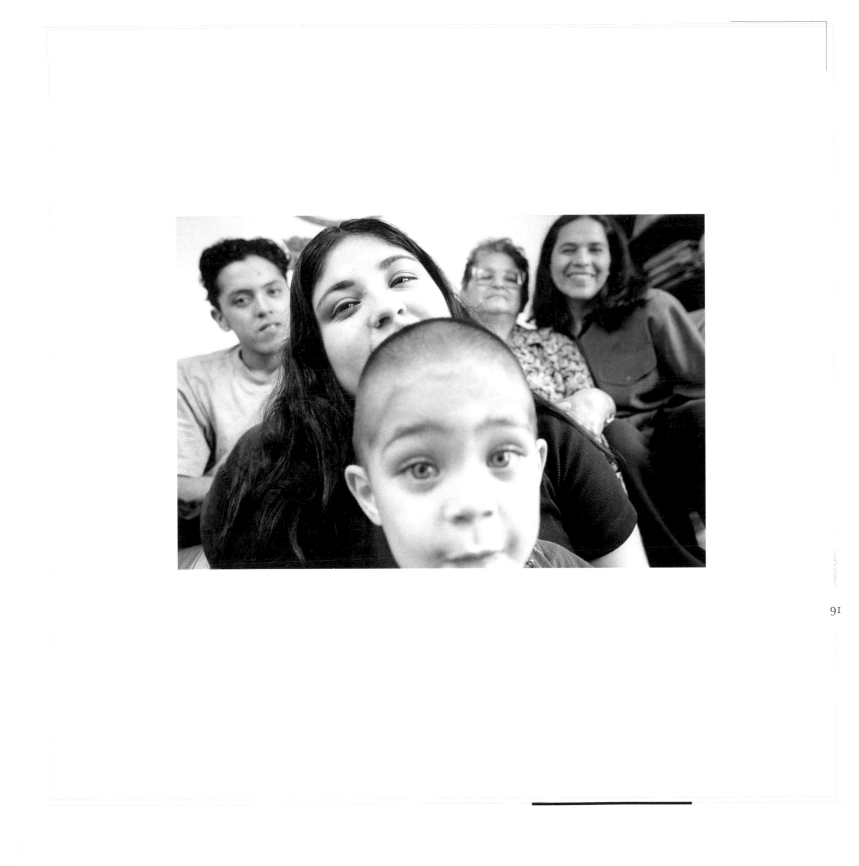

I was the first one of my friends to have a baby, and then two of them had kids after me. I think my friends' moms looked at me in a bad way because they thought I might influence their daughters.

There have been lots of times when grown-ups have looked down on me because I'm young. They'll look at me like **"Oh, she's done and over with. She cannot be anyone. She already has a son. She messed up. She's a tramp."** And even if that person is intellectual, I think they're ignorant because they don't know my life and how it has been for me.

I live in a three-bedroom apartment with my grandmother Maria, my sister Frances, my brother Rommel, my aunt Gloria, my aunt Maria Elena, her husband Ray, and of course, Joseph, my son. I share a room with Joseph and Rommel.

I like living with my family. I like being around a lot of people. I know that some families—mostly White people—they're used to having their kids or their husband and that's it. But us Latin people, we live together. We're used to it.

I'm a pretty stubborn mother. I listen to my aunts and to my grandmother, but when it comes to Joseph, if I don't like what they tell me, I do things my way. That's when I get into fights with one of my aunts.

Even though she loves Joseph now, she didn't want me to have him because I was only sixteen when I got pregnant, and she thought I was very immature. I had been messing around in school and only wanted to party and worry about friends. We were living in California, and my aunt got very upset with me and sent me back to Nicaragua, where I was born, because she wanted me to see how life is, that life isn't just about a joke and partying. Nicaragua is a poor country and she wanted me to know what I have, even if it is very little, and to learn to appreciate it.

So I went to Nicaragua and made a lot of friends, including Daniel, Joseph's father. He was a very nice guy. He treated me nice and never disrespected me. He was the first person I ever had sex with, and I guess that's why I got so sprung on him. You want to cherish the first one, you know.

One day he asked me, "Do you want to have a son with me?" It was very childish of him and I told him no. But he kept asking me, "Do you want to? Do you want to?" And I kept saying, "No, no, no." And then I finally accepted it.

92

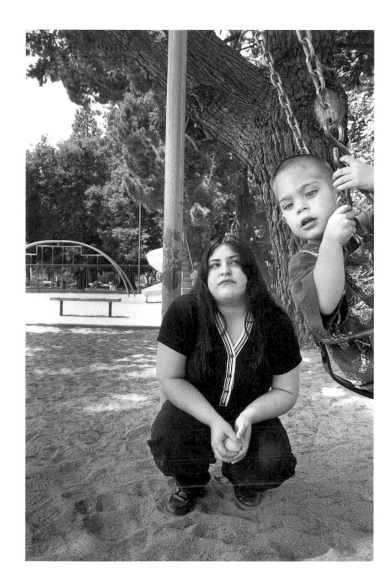

I didn't think about the consequences. I went a little cuckoo. After I got pregnant, Daniel came to live at my mom's house with me in Nicaragua, and I was very happy. But shortly after that, we started having problems because I found out he was fooling around with other girls, and I didn't think that was fair of him. I mean, I got pregnant mostly because I wanted to please him, and now he's out there playing on me. I thought he was going to be around for the rest of life. I thought it was going to last forever.

I came back to California when I was four-and-a-half months pregnant, partly to punish Daniel, and also because I was having problems with my pregnancy; Joseph kept wanting to come out, and they didn't have the best medical situation in Nicaragua to deal with that. My aunt and I argued a lot back in California. I told her that I would have never gotten pregnant if she hadn't sent me to Nicaragua. I was upset. I said some things I shouldn't have. I realize now that she didn't want me to have the weight of having a child. She wanted me to finish high school and become someone.

But I always kept it in my mind that I was going to get back together with Daniel and be a family. And **having his baby inside of me kept me feeling close to him and the dream of being together, even though he was still back in Nicaragua.** Sure I was scared about being pregnant, but I thought it would all work out.

Two and a half years later, Joseph has still never met his father. When he was little he carried his father's picture around and kissed it, but now he doesn't pay much attention to it. I haven't heard from Daniel in a few months, and I'm sure that we will never get back together. **I don't regret having Joseph in my life, but I think men are liars.**

Emotionally, I have matured ten years. Before I had Joseph I helped my grandmother with babysitting, but being a mother is different from babysitting because even if you don't feel like changing a diaper or going for a walk, you have to. You need to be mature to have a baby, so you'll know what's best for your kid and how to raise them to become a good citizen. **Anyone can change diapers.**

For me, it's been helpful to have my family around. If I need anything or want to talk to someone, they are there. I usually go to my grandma though, because she raised me since I was three months old, and I feel good telling her things. She gives me the best advice, even though sometimes her ideas are old-fashioned. Like she has these

94

her ideas sound great, I just never want to try them

home remedies for when Joseph has a cold or a fever and she'll say, "Oh, let's give him this medicine with these herbs," and I'll say "No, no, no! I already called the doctor; I'm giving him Tylenol!" Her ideas sound great, I just never want to try them on Joseph.

My own mom was an irresponsible teenager. She had my sister at fifteen and me when she was eighteen. After I was born, she met my brother's father and left us behind. **I could never understand how a person could leave their three-month-old baby behind.** Even though I had my grandma, my great-grandma, and my aunts, who have all been great, you can never compare the love of a mom.

We came to the United States when I was eight years old, and I didn't hear from my mom again until I was fifteen. She never wrote or called, and I always asked myself what I did wrong. I was bitter and hurt for many years. I closed down and never showed emotion to people. But since having Joseph, I have come to forgive her because even if your mom is the worst person in life, you always have a love for her.

Now that I'm a mother, the most important thing to me is to know that Joseph feels loved. And so I have had to learn to express myself emotionally and say what I think and feel. I've always said "I love you," but now I give my family hugs, and I tell Joseph that I love him and that he's a good boy. **I guess I'm trying to be the mom that my mom wasn't.** I'm not saying I'm perfect—no way Jose—but I try to be the best I can.

It's important for me to be somebody. I want to prove it to my aunt and to her friends and anyone else who feels that a young person having a baby means their life is over. Mostly I want to prove it to Joseph by never turning my back on him, not for another man, not for nothing. Maybe one day I will meet a man I can trust, a man who could love Joseph like his own. Maybe I will find that person, but if not, that's okay. Life is not just about having a guy around. **I admire ladies who make it on their own.**
 If they fall down, they get up and try again.
That's what I try to do.

BETH LEE VERRET

BETH LEE VERRET IS FORTY YEARS OLD AND THE MOTHER OF RACHEL EVAN VERRET, WHO IS FIVE.
BETH WAS EXECUTIVE DIRECTOR OF AN INTERNATIONAL ARTS ORGANIZATION
AND HAS WORKED WITH MUSICIANS AROUND THE WORLD
FOR THE LAST SIX YEARS. HER HUSBAND ERROL
IS AN ACCORDION-MAKER AND MUSICIAN.

I was raised to be a perfectionist. As a Jewish woman, I'm trained to do everything well and to see myself through the eyes of other people. I evaluate over and over again the things I've done wrong, and I tend to brush my achievements under the carpet. A close friend of mine said "But Beth, that's how you strive to get better." But I think you can take it too far. Most of us, women in particular, need to sit down and enjoy our achievements, because we can spend too much time dwelling on our failures.

A few years ago, I was the director of an international arts festival, a sixty-hour-a-week job which had become my life—totally stressful—but I loved it. Career has always been really important to me because my view of myself has always been dependent on whether I felt I was making a contribution in the world, and I tend to be pretty hard on myself about that, so I worked like a dog.

My daughter Rachel was a surprise. I'd never seen myself as a very mothering kind of person, and yet after she was born, I was shocked by all my maternal, protective feelings and felt torn at having to divide my time between mothering and work.

My job had become particularly stressful for a lot of political reasons. But when things got rough, I just worked harder because I thought I could fix all the problems—which was *my* problem. I took it all to heart and took it home with me every night. My husband and my home life were definitely neglected during those first few years of Rachel's life, but at the time I just wanted to be all things to all people.

Then **three years ago, when Rachel was two, I started having these weird sensations like I was wading through water all the time,** but I didn't know what was wrong with me. I'd gone to the doctor because I had a lump on my neck, and they did a needle biopsy but said it wasn't cancer. They wanted to take it out, but I was busy with the arts festival and I forgot about it until six months later when I noticed a large lymph node on my arm.

Then I was diagnosed with lymphoma.

One of the first thoughts I had was that I wasn't going to see Rachel graduate from high school and that just seemed like the worst thing in the world to me. I cried all the time and never slept because I kept wondering who was going to take care of Rachel when I was gone.

I'd never seen myself as a **very mothering kind of person**

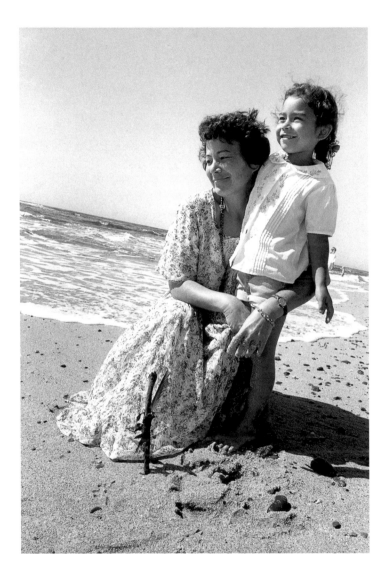

My doctor was more hopeful. He said lymphoma was one of the best cancers to get because they have a lot of treatments for it and they're generally very effective. They thought that once I went through the first round of chemotherapy I'd be in remission. But what he didn't tell me was that I had tumors throughout my body. He wasn't trying to hide anything from me, but he's an optimist, and I think he didn't want me to focus on the negative side of my illness because I might not get better.

I held onto my job for two more years after I was diagnosed, even though the pressure itself was killing me. **Quitting, which I eventually did, felt like a failure to me even though my life was hanging by a thread.**

The last three years have been a long series of treatments and transplants, tests, a million medications, and visits to hospitals around the country. Although Stanford Medical Center, my doctor, and all the experimental treatments have prolonged my life, I'm not in remission yet, though I do have fewer tumors in my body. I'm still considered a terminal patient, though.

Rachel knows I have lymphoma, but she doesn't know that it's a potentially fatal disease. She doesn't connect it with cancer, and I ask people not to call it that in front of her. We call it my *phomas* and we call the antibodies I take my *phoma fighting forces.* We heard *Star Wars* on the radio the other night and since then she's been going around saying, "May the forces be with you, Mom." That's so cool.

I think the hardest thing for her is that Mommy's always tired. We do a lot together, but if I had my normal energy I could do so much more. I take her everywhere I go though, like I have a lot of friends who play music so I'll sneak her into a club, or if I give a talk, she'll be listening. I'm so aware of the time we have together, and I'm constantly looking at how we use that time.

In the beginning, I did really funny things, like I'd buy her clothes. I didn't know if I'd be alive this fall, so I bought all her school clothes. And sometimes I'll buy her her older clothes and leave notes on them like "Mama bought this for you." It's a really bizarre thing to do. **I know my husband is going to deck her in jeans, so I wanted her to know that Mama bought her the pretty clothes.** But then after a full day of running around shopping, it hits me how ridiculous that is because I'm exhausted and have to go lie down and we haven't spent

99

so I'll **sneak** her into a club

real time together, reading or watching her jump rope and giving of myself, which is the most valuable thing I have these days. I mean, **what's she going to remember?**

That her mama bought her that sweater or that her mama read with her?

I read this book about girls Rachel's age who'd lost their mothers, and it was so painful to read that most of the daughters didn't remember much about their mothers. So I've been trying to prepare for this having my husband take pictures of Rachel and me together, something I never liked by to do in the past because I didn't like the way I looked. And sometimes I'll write little diary excerpts in the computer about something that Rachel and I have done together or something funny that she's said to me. These are things for her to read later.

One of the hardest things is to imagine letting go of Rachel and all that I want for her. I'm the one who really focuses on her, who makes sure she gets to dance class, and who wants her to take French and prepare herself for college. Even though my husband loves her and is very caring, it wasn't the pattern in his family for the father to focus on the children, and it scares me to think of Rachel being reliant on him, even though I know he'll pull through and she'll be fed and loved. But her life will be very different without me. I can't stop thinking that she needs her mama.

But I can't dwell on that because it's not the here and now, and I don't want to waste my time worrying. In the last three weeks, three of the people who I was on this trial treatment with have died. One of them had even been in complete remission a few months ago and now he's gone. I'm the only one alive from that group. So this reminds me to live in the now. Nothing can matter except being with my daughter and my husband.

I guess what the illness has done—and it's taken a couple years for it to really get through to me—is make me understand my priorities and refocus my energies. For the first three years, I was totally focused on doing whatever it took to be cured. I went head-on into healing with the same intensity I brought to my work. I used to joke that I was dying to live. But it's true. **And when I fight this disease,**

I do it for my daughter. I'll do anything to stay with her.

These are things for her to read later

But last spring, something really changed in me. I had a transplant, which was something that could potentially cure me and put me in a long-term remission. But afterwards they told me that it wasn't going to cure me, and that it meant my life expectancy was not very long. I realized that if I'm going to die, I'm going to die. And something really let go in me, and I began to see life more on a daily basis and realize how lucky I was to have healthy days, and to have my beautiful Rachel, and my great husband.

In many ways, my life is so much more fun today than it ever was because I'm seeing things so differently, so much more in the now. Like I dance more. I was always too inhibited before because I didn't want to look silly. But after I lost my hair four times and looked like total crap, I realized that I had nothing to lose, and that people enjoy people who are having a good time, not people who are perfect and who have every hair in place. **These days I focus less on whether I look like a fool and more on living my life and having a good time.**

And Rachel emulates this. The other night we were at a restaurant and a belly dancer pulled her out of her chair, and she got up and danced with her. She'd seen Mama do it, so she did it, too, and I was so glad to see that. **I want her to feel the freedom that comes from feeling good about herself.**

I'm also more focused on my mothering. Today I can say that I'm proud that being a mother is my job. Years back, when I was working, the thought of being a homemaker was an impossible thought because I had a hard time valuing myself in that role. But today that's what I am, and I appreciate this chance to slow down and be with my child.

In some ways my illness has been a real blessing for me. It's taken me on a journey that I might not have made if I had been well. It's helped me to slow down and be present to what is in front of me, and for this I am grateful. **Life is now.**

Debra Ball is the thirty-eight-year-old mother of Chloe, who is nineteen months old.
She recently quit her job as a traveling saleswoman to devote herself to
Chloe and to ready herself for the birth of a second child.
She lives with her husband Bill, a salesman, in the South.

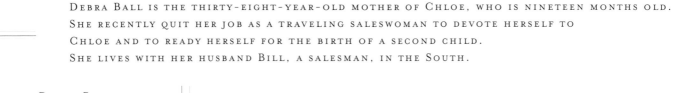

Debra Ball

Somebody once told me that you could begin to understand the love that God has for
us once you have a child, and since I've had Chloe, I know exactly what they mean.

You should see the way her face lights up when she's happy. Her joy is so pure. It's
the same when she cries. She just cries. And when she's mad, she's mad, and I delight
in that. **She's just pure emotion and has no reason to be ashamed or cover up anything she feels.**
And this is the gift for me, just to be around such a healthy, pure being.

and when she's mad, she's mad

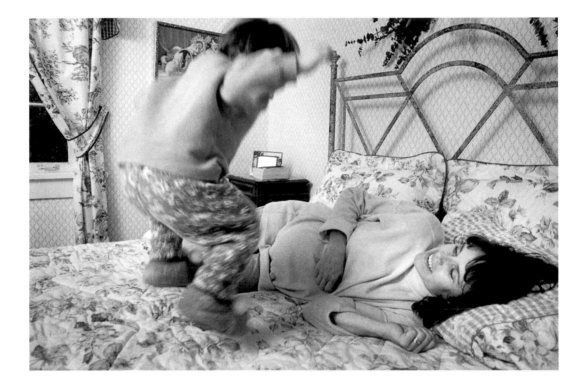

When I was younger, I think I was a fairly joyful person, but then somewhere in my early twenties I became very serious, and everything had to be done right; I had to set the world on fire and make my sales numbers and win awards and climb the corporate ladder. And with that came all these responsibilities and bills to pay, and it seemed like I never had a spare moment to breathe.

Becoming an adult was overwhelming at times. I found happiness in superficial things, like if I had a date or if I bought new clothes or a new piece of furniture. That was how I gauged my joy. But I wasn't really happy. And I made a lot of serious mistakes, too—you know, the things so many of us did, the sex and the drugs and a number of things that I don't think I'd like to see in print. I remember praying that I wouldn't die just then because if I did, then I would surely go to hell. I used to say, "Lord, please be patient with me, because I need to have a little more fun just yet."

But **as a mother, I realize that most of the things I thought were important weren't.** None of those things can compare with seeing how excited Chloe gets when I take her to the pet store to look at the iguanas and the fish. That's where my true sense of joy is found these days, especially since I quit my job and became a full-time mother.

I used to work for a medical supply firm and my job was to travel around selling breast pumps, among other things. I liked my work and I was good at it, though I was not delighted to have to return to it six weeks after Chloe was born. My husband Bill, who was unemployed at the time, was her primary caretaker for the first ten months of her life, which was wonderful for their relationship. But meanwhile, I was gone Tuesday mornings through Thursday nights, and I found myself missing this little person so much.

It was a lot of pressure: the deadlines, the traveling, the phone calls, the paperwork. Some women are wonderful, they can juggle everything, but I was stressed and hurried all the time. I'd be sitting with Chloe playing blocks, but **in the back of my mind I'd be thinking about the report I had to write or a phone call I had to make.** I wondered what I must look like to her, and what message I was communicating nonverbally. I'd have to stop and make myself smile at her and try to wipe away whatever else I was thinking about.

I was stressed and hurried all the time.

I got really depressed and began to dread my sales trips out of town. I'd be selling in these hospitals, and I'd see the babies in the nurseries and just cry because they looked so little, and I'd think, "My daughter is getting so big." It wasn't one of those things like "Oh, I missed her first step or her first word." It was more like I was missing out on the joy of Chloe.

By then it had started to affect my marriage. Bill knew I was stressed because I'd get crabby, and one night I said, "Honey, how does that Carly Simon song go? 'These are the good ol' days'? 'Cause things are going by too fast for me. After I come home from a three- or five-hour sales drive, I'm exhausted, and I feel like I've missed so much here at home." I didn't want to look back on this time and feel like I blew it because I was more concerned about work than I was about my daughter—because **maybe these *are* the good ol' days, and we should take hold of them and really live them.**

So two months later, I quit my job. We decided to bite the bullet, have less income, but more quality in our lives. We were just lucky that we could do that.

Now when I'm with Chloe, I'm fully with her, and I appreciate that I can relax and concentrate on being a mother. And **if I've learned anything from her, it's to be more joyful and to take pleasure from the simple things,** because Chloe lives in the moment.

The future is not a concept she understands at nineteen months old—unlike us grown-ups who are always looking ahead and planning and saying things like "Things will be better once I get that promotion or once I graduate college" or "I can't wait until Christmas." But in the meantime, everything just slips away from us. Chloe is teaching me to appreciate that moment because that's where joy lives, even if it looks as insignificant as sitting on the floor building some blocks or playing dress up.

This is going to sound kind of strange, but when I was pregnant with Chloe, I always thought that there was something really special about her. Something really spiritual, like she was going to do something great in her life. Maybe every parent says that, and then their kid ends up on top of a building with an Uzi machine gun, but I really did feel like this baby was going to contribute something vital to the world. Whether she does or not, she's already given me my gift, which is the joy and love that I sought for so many years.

LAURA BOHOR ROTH

LAURA BOHOR ROTH IS THE THIRTY-SIX-YEAR-OLD MOTHER OF FIVE-YEAR-OLD ABIGAIL CALLAWAY ROTH
AND TEN-MONTH-OLD HANNAH GRACE ROTH, WHO WAS BORN WITH DOWN SYNDROME
AND A CONGENITAL HEART DEFECT. LAURA IS MARRIED TO
MARK ROTH, A SCIENTIST.

My husband Mark wants me to write a book called *When God Has Down Syndrome* because he feels that **Hannah knows everything and that she whispers the secrets of the universe** to him when he holds her close at night. Our theory is that she's connected to God because of the hole in her head, her fontanel, but that after it seals up she'll be stuck down here with the rest of us stupid, thick-skulled people on the planet. It takes kids who have Down syndrome longer to lose the soft spot, so we feel that we have a greater opportunity to learn from her.

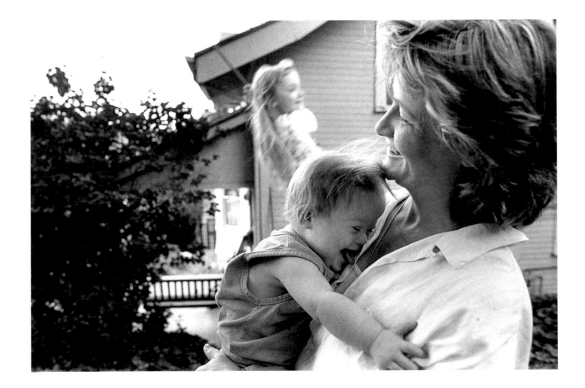

Maybe that's just our way of accepting the reality of having a child like Hannah, but it makes sense to us.

I think we spent the first week after she was born just sobbing about the Down syndrome. We were so totally in love with this child, and the enormity of DS—the lists of things that could go wrong, all the medical complications, and her future—just destroyed us at a time when we were already basket cases, all emotional and sleepless. We had to marshal all the energy we had just to get her to eat, feeding her through a syringe every two hours while she sucked on Mark's fingers. After a week of this, when we thought we'd gotten through the worst part, the doctors told us about her heart defect. They didn't give her great chances to live without surgery, and even with it, her chances didn't sound so great. And then we just lost it. The pain about the Down's just fell away in the face of this bigger thing. Her heart. We could work with the rest of it, love would work with everything else, but this was way beyond our control, beyond our power to change.

Later we realized that Hannah's heart, in the way you and I speak of hearts, was pretty perfect. It was our hearts that would change.

If anything got us through the curve balls of those first weeks, it was our five-year-old, Abbey. Our friends were really wonderful, too, leaving little gifts of food—in some cases lavish dinners—on our porch like little fairy offerings. Other friends took Abbey away for entire play days, and she felt like quite the popular kid, which was good because I was starting to worry about the amount that she was watching us cry.

Early on, Mark and I made a pact that only one of us was allowed to lose it at a time. So if one of us was crying, the other was required to keep it together and act nonchalant, like "Oh, Mommy's crying right now because she's sad, but she'll be better in a little while." We were worried that seeing us so emotional could be really destabilizing. Abbey was so completely in love with Hannah right from the start, and it was this fierce devotion, this adoration of her baby sister that shook us up and brought us back down to the ground.

Abbey swore that she was the happiest kid in the world. She'd run up to strangers in the grocery store and shout out car windows "I'm a big sister now!" Listening to her tell people in the check-out line about her baby sister Hannah Grace Linden Roth Lovey, and how cute and sweet she was, and how she couldn't wait to share her room with her, and how, someday, they'd have bunk beds and she'd read to her at night— well, it was enough to break up whatever pity party we were having for ourselves pretty quick.

if one of us was crying, the other was required to keep it together

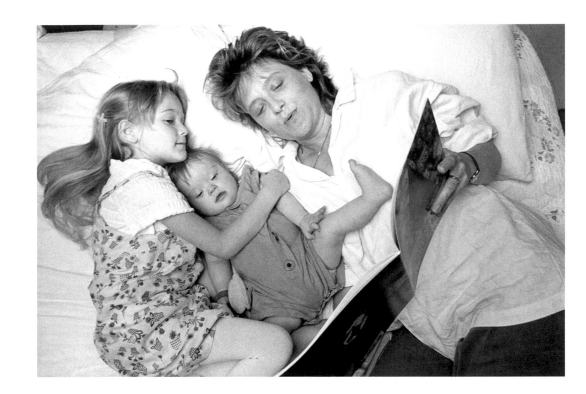

Abbey thinks Hannah is perfect the way she is, but she has finally begun to notice some differences. About a month ago, she came in all excited and said, "Mom, Tamara's baby is younger than Hannah and she's already sitting up! Can you believe it?" So I sat her down and asked her if she had heard us say Down syndrome before and she said yes. And I said, "Well, what Down syndrome means, besides her heart problem, is that Hannah is going to do everything slower because her muscles aren't as strong as most people's. And that's why she can't sit up yet. She will sit up, and she will crawl and walk, but it's going to take her a bit longer than other kids." I tried not to say "normal" kids, just other kids. And she said, "Okay, that makes sense."

Mark and I talk a lot about why Hannah is here. I went from a place of thinking, at first, "Why me? This can't happen to me. I'm not supposed to be driving special-ed car pools for the rest of my life—I have all these other things I'm supposed to do," to feeling like "Well, maybe this is exactly what I'm supposed to do." I mean, no matter what my fantasies are of who I'm supposed to be, and no matter how many lists I've made since I was about eight years old about the things I wanted to accomplish in my life—the fact is, I'm an at-home mom who's raising her kids. Maybe Hannah Grace needed to be born to somebody who was going to stay home and just love her. Maybe she's here because I never am going to follow through and have some great outside career.

But now that we've traveled down this road a while, we know that **Hannah Grace has brought about a revolution in our way of living, our attitudes about time and love and what really matters.** When I was about twelve years old, I'd copy little quotes about life and love into notebooks and journals, things like "Live in the moment!" and "Savor the day!" But then you grow up, and life kind of gets in the way until you're brought back to those deeper truths—you're picking out a Hallmark card with five minutes to spare at the grocery store and there it is, you know, "Ah yes, we should live for the day, we should."

And then someone like Hannah Grace comes along, and you finally live it, and there's such revelation in that. **It's such a huge gift that she's giving us, this living in the now, in the moment, and it's so much about love and joy and having fun, that we have to believe that she's gonna stay with us** so that we can give something equally wonderful back to her. A happy childhood, if nothing else.

But we're not always so calm and philosophical about it. A couple of weeks ago, we had this gorgeous day in the park, and it was just so beautiful, I couldn't stop crying. I kept telling Mark that it wasn't enough to live for the moment anymore. I want to know that there will be more of them, and that our future includes Hannah Grace. I'm

having a hard time with it now, especially, because she has another heart catheter coming up, where doctors will assess her heart and lungs for open-heart surgery, possibly for this summer.

We've been living in limbo, with this idea that the surgery could be tomorrow or next week, for the entire ten months of her life. She could be home in four weeks and survive it, or she could be in the hospital for four months. And there is a chance she could die. We're looking at this completely unknown future, and it's too hard to think about. We basically try to ignore it.

Describing Hannah's medical condition has a tendency to bring me down because very few people can get past it and really see the gift of who she is. **In purely technical terms, Hannah sounds like a tragedy. But the reality of her is just the opposite.** I remember during the first week when Mark would be in tears, crying for the chances Hannah wouldn't have in life, I'd place Hannah on his chest and he would stop crying. We called it "Hannah Therapy," because when you reach for her, her whole body lights up with so much love and happiness.

And there's something about the way she smiles at us—this big, slow smile—that is so full of meaning. It's like she's saying, "Aw, you guys. I love you. Don't worry."

I remember when Abbey was an infant, I was petrified that she would fall asleep and never wake up (even though I know this is a common thing, this fear) because somehow I deserved punishment for not being a good enough mother, not cherishing her enough every moment of the day. Whereas with Hannah, her so-called problems are so severe, she really could simply go one night. But, instead, we all sleep just fine. **If God wants to take her, he's just going to take her,** and in the meantime, we just have to be strong and try not to control the universe and get some sleep.

But every night before we put her to bed we whisper in her ear,
"Stick around, honey. It'll be fun. Please stay and grow up with us."

About two months after this interview, Hannah Grace died from complications
following her open-heart surgery. Though she's dancing with the stars now, her family can still hear
the secrets she whispers to them at night.

BELLE DE DIOS-COHEN

BELLE DE DIOS-COHEN IS THE FORTY-TWO-YEAR-OLD MOTHER OF WILLIE, WHO IS SIX-YEARS-OLD,
AND KYLE, WHO IS ELEVEN AND WHO WAS ADOPTED AT BIRTH BY A COUPLE IN CALIFORNIA.
ORIGINALLY FROM THE PHILIPPINES, BELLE CAME TO THE UNITED STATES IN 1983 AND, FOR THE LAST
FIVE YEARS, HAS BEEN MARRIED TO WILLIE'S DAD, JEFF COHEN, A BODY WORKER. BELLE IS CURRENTLY
WORKING FOR A NONPROFIT AGENCY FOR SEXUALLY ABUSED CHILDREN.

Yesterday morning I woke up and immediately got into an argument with my husband.
I don't remember what it was about, but he'd said something that really upset me, and
even though I didn't become my hysterical self, it put me into a bad mood. Willie, our
six-year-old daughter, was in bed with us at the time, so she starts whispering, **"Mommy, Mommy,
calm down. Calm down, don't say anything."** So I decide that I'm just going to calm down
and not say a word to my husband.

Later, at breakfast, my husband apologizes, but I get mad all over again, so he takes
Willie to her room to talk because he doesn't want her to get traumatized over the
argument. A few minutes later, she comes out and she says, "Okay, Mommy and
Daddy, do you want to learn something that I can teach you?" "What?" we ask her.

I didn't become my hysterical self

And she says, "Okay, now, **because of you and Daddy, I have strength. Your love gives me strength.**
So, what about if my love for you, and your love for Daddy and Daddy's love for you
can give you strength? Then you don't have to fight." And we're standing there with
our eyes wide open, sort of speechless, and then of course she wants the big family hug,
and what could we do? We had to make up.

Willie grounds me. My tendency has always been to be a carefree spirit, self-centered, always living
for the here and now, and traveling whenever I got bored. **My life had no goals before I became
Willie's mother.**

I know she's only a kid and her job isn't to ground us, but I think kids do show you
lessons if you pay attention. My lessons have to do with nonattachment—but that started
when I had my son Kyle, eleven years ago.

I was thirty and on my own when I became pregnant with Kyle. I'd always wanted
a baby, but I didn't want to be a single parent, either. The next thing I knew, I was
sitting in this lawyer's office looking through albums of secure-looking couples show-
ing off their homes and talking about how their lives would be complete if they only
had a child.

These were people who had everything a child could ever want, while **I didn't feel that I had anything
to offer my child, at least materially.**

I know people wondered how I could just give him up, but at the time I had been
reading some Buddhism, and the philosophy of nonattachment helped me to under-
stand that I was giving up my child as part of the flow of life, and that wanting the best
for my child might not mean being with me. It was still hard to give him up, but what
made it so much easier was his adoptive family and the magical connection we had.

The woman's name was Isabelle, which is also my name. She's exactly my height, is
French, and a gourmet cook. I've lived in France, speak French, and was working as a
sous-chef when I got pregnant, so we had all these similarities. She and her husband
had this lifestyle that I'd always envisioned for myself; they lived in a beautiful house,
entertained freely, were financially stable, and had time to enjoy life. But to make
myself feel even more right about them, right before the birth I went to a channeler
who said that Isabelle and I had been sisters through different lifetimes, helping each

other out, and that it was my turn to help her. So it all made sense to me.

I gave birth in the town that they lived in, and afterwards, six of Isabelle's women friends took me up to this cottage in the mountains where I stayed by myself for two weeks. Every afternoon one of them would come with my dinner and massage my feet or bring me flowers and comfort me. **They wanted to create a time for me to grieve my loss and begin to heal.** Down in town, six of Isabelle's other friends were taking care of her and treating her as if she'd just given birth, bringing her food and helping her with Kyle, her new son. I cried everyday. It was one of the most beautiful and painful experiences that I've ever had.

Since it was an open adoption, I went down to their home whenever I needed to see Kyle, which was a lot. Isabelle and her family would pick me up from the bus station, and I'd spend the day with them. Before I'd get there I'd be a wreck, but **when I saw the connection between Kyle and Isabelle, even when I saw them hugging and kissing, it was so beautiful that I would often cry, but I would never feel jealous.**

Kyle was always aware that I was his birth mother, and his family made room for me in their lives. On his fourth birthday, I helped him bake a cake while his mother got other party things ready, and a few years later, when he was seven, he said to his mom, "Let's send Belle a card and thank her." God, that was so beautiful. It made me cry because it meant that he was happy and that I'd done a good job.

Kyle is my lesson in nonattachment, plain and simple. I love him, I'll always be here for him if he ever needs me, but I don't feel the need to possess him.

I try to remember this feeling of nonattachment when I'm being obsessive and acting neurotic with Willie, like when she has a little fever and my mind imagines the worst, or when I go to her school and see all the other kids' paintings on the wall, but not Willie's, and I find myself going up to the teacher to find out where Willie's work is—I mean, that's a little obsessive.

So I try to remember Kyle at those times, so I can get some perspective. But it's not always easy, because I love Willie so much and we're so bonded. **When she went to kindergarten I cried; when I see her climbing up trees my heart is up in my throat.**

Maybe part of motherhood is learning to live with the kind of intense attachment you feel for your kid, and that feeling of wanting things to be a certain way for them. So just as I had to learn to let go with Kyle, I have to learn how to live with my bonded feelings for Willie. I think it's a matter of finding the balance.

115

I'm being obsessive and acting neurotic

TWENTY-YEAR-OLD JODY LYNN REMBOLD HAS BEEN ADDICTED TO HEROIN AND SPEED OFF AND ON FOR THE LAST FIVE YEARS. HER DAUGHTER, SAVANNAH RENE THOMAS, IS FIVE MONTHS OLD AND LIVES WITH JODY IN A TRANSITIONAL HOME FOR HOMELESS MOTHERS.

JODY LYNN REMBOLD

When I found out I was pregnant I was living with this guy on the streets of San Francisco and basically just running amuck out there, doing a lot of speed and heroin. The guy, Robert, was really excited when he found out we were going to have a kid, but I was scared because I knew that I was going to have to quit doing drugs, and I wasn't really ready to do that.

I tried to slow down after that. I was still using every day, but I tried to limit the amount. But the fear of knowing that I was going to have the baby, combined with living on the streets, made me end up getting addicted to heroin again and using more than I ever had.

I lived on the streets during my whole pregnancy, sleeping under bridges and in parks and eating out of dumpsters.

I used to cry when I was fixing because I'd think about the baby. But as much as

I hated what I was doing, I couldn't quit.

I figured it was better for me to stay high because it was worse for the baby to get sick from withdrawal than it was for her to be high. I mean, she'd withdrawal when I'd withdrawal, and I could tell she was sick because she'd start moving around a lot.

I felt guilty about what I was doing, but after I got high, I didn't feel anything. The thing about heroin is that it makes everything okay. Even though everything is really, really bad, it's okay for that moment because you're high, and as long as you stay loaded nothing really matters.

We talked a lot about the baby when we were high. We'd say, "We're going to quit doing this. We're going to get our shit together. We're going to have a nice family." That was our dream even before I found out I was pregnant. We wanted to get clean and start a family, but the addiction makes you do some weird things. It's very snaky, and it tricks you. One night I dreamt about my baby fixing—because that was basically what was happening—I was fixing her.

I think it was in my sixth month that I ended up calling my family and going out to my mother's house. It was Christmas Eve. My father had found me a methadone program, and I went to stay in a residential treatment program for the last two months of the pregnancy.

I had Savannah in the hospital. When she was born, she detoxed off of the methadone. It was awful. She went through the same kind of withdrawals that I go through; she shook, she had diarrhea, she couldn't sleep well. The worst part was watching her shake. But she was okay, considering I used a few times a day for six months of my pregnancy. It's scary, but I know so many babies who were born to people who used like I did throughout their pregnancies and who turned out fine.

Of course, as she grows up she may have some adverse effects. She may have that attention deficit disorder. She might be hyper or something. I don't know, we'll see.

Now I live in a transitional house. I have a room in a clean and sober living area for homeless mothers and their children. It's been good for us, but I've been back to the city quite a few times already. I wheel Savannah's stroller into Chinatown and we find Robert, and then we get loaded. **Since I've had Savannah, we've been getting a motel room at night instead of sleeping on the street.** I can still take care of her when I'm high, except it seems like the longer I go out there, the more junk I do. I think the higher I get, the harder it's going to be. **Usually I'm a very attentive parent, but when I'm high I forget little things like changing her diaper.** That shit is kicking my ass.

Savannah knows what's going on. She has to notice a change in me because mothers and their children have a connection. And no matter how normal I try to act, she senses what I feel. She can't put a name to it, but she feels that something isn't right. And for that I feel really guilty.

It's weird, but I'll be washing dishes or bathing Savannah, and before I realize it, I'm making plans to get myself to the city—which bus to take, how much time I'll need, and how much money to take. I can't get the thought of using out of my mind. **It just rules my thoughts.**

it was awful

But drugs are in my genes. I was born to addict parents and I was left by addict parents. I grew up without my real mother and father; I was adopted by my aunt and uncle when I was three. **I knew that somewhere out there, there were these two people who, for reasons that I couldn't explain, didn't want me.** As a child you don't understand that.

Growing up, I had visions of walking the streets and being a dope fiend. I remember that. That's what I was supposed to do. It seemed exciting. That's what my real parents did.

I realize that the same thing is happening to Savannah that happened to me. I realize that the pattern is repeating itself. But knowing that isn't always enough to stop me from catching a bus into the city.

If anything could possibly stop me, it'd have to be Savannah herself, who I have no doubt is a gift from God. She says to me, "I'm your chance, your reason to do something other than what you're doing." When I look at her I don't see any bad. She is a completely pure and good person. And that helps me to remember that I started off like that, too, even though the trouble started so early in my life. At one point, I was that pure innocent child, and it must still be in me somewhere because I can relate to Savannah. **She reminds me of life's goodness, the other side of life that I don't pay a lot of attention to because I'm not used to seeing it.**

She makes me want to feel that goodness. She helps me to stop and look at the trees and point out the little things. Even though I'm still an addict, **being a mom has been the best thing that's ever happened to me.** The connection between us is amazing. There's so much love in her, and it rubs off on me. The mornings are my favorite because I'll put the radio on and we'll dance. Then we'll take a bath and I'll clean her up, make her smell good, and put nice clothes on her. I love knowing that I'm taking good care of her. Mostly I love seeing her change and grow and knowing that I'm helping that along and that she needs me to be there for her. No other person can do what I can do for her because I'm her mother.

she says to me, I'm your chance

And I have seen changes in myself. I'm seeing a bigger picture of life. Things that I used to find acceptable, I have a harder time with. Now when I go to the city and I have her with me, I get embarrassed when I walk down the street because I know I'm not supposed to be there. Or when we're walking with Robert, I'm wondering if people are looking at us and trying to figure out if he's her father and why a mother and her child would be walking with this guy who's obviously not clean, and looks and acts like a junkie. **I know I have so much work ahead of me. It would be so much easier to go back to living on the streets and doing dope.** But if I was to look at my life, and all the things I don't have, and all the work I have to do to be a successful, healthy person, it would feel so hopeless. I wouldn't even bother trying. So I have to take it one moment at a time and say, "Right now I'm not going to get on that bus, and I'm not going to get loaded." I mean, I'll get to the point where I can almost pull my hair out because it drives me insane. It's gotten so bad I almost spin in circles and start talking gibberish because it won't leave me alone. I get that feeling every day.

It helps me when I look at Savannah. I talk to her and I say, "Mom's going nuts right now. She wants to get loaded, but she can't. We're not going to the city today, honey, we're not going. Mom's going to take care of you." I just keep repeating that over and over to her.

"Mom's going to take care of you. Mom's going to take care of you."

*A few months after this story was written, Jody had been clean and sober
for three months and was looking for a place to live with Savannah.*

CAMARA MERI RAJABARI

CAMARA MERI RAJABARI IS A TWENTY-SEVEN-YEAR-OLD SINGLE MOTHER WHO LIVES WITH HER FOUR-YEAR-OLD SON
DILIZA MADUBUIKE RAJABARI IN A SMALL APARTMENT. SHE WORKS FULL-TIME AS AN ASSISTANT
TO THE BUYER FOR A NATIONAL RETAIL CLOTHING COMPANY.
SHE HOPES TO GO INTO SOME KIND OF COUNSELING
WORK IN THE FUTURE.

When my son was born, I wanted him to have a name that would remind him of
who he was, so I chose Diliza, an African name, because it means destroyer of evil, and
Madubuike because it means man gets his strength from his mother. And I changed my
name from Cynthia to Camara, which means one who teaches from her experiences.

The name change was important to me. At the time, **I was going through a real identity thing
around being a Black person in this culture,** and finding our names helped to support my decision
to go ahead and have this child as a single Black woman. I knew it was going to be hard,
and the names conjured up a strength I think I needed.

I gave a lot of thought to having Diliza. His father was a casual boyfriend who was
separated from his wife when we'd gotten together, and while I'd thought things were
more serious for us, and that his separation meant they weren't seeing each other, it
turned out not to be true. Now I look back and think, "Duh! What was I thinking?"

finding our names helped to support my decision

Anyway, he tried to dump the responsibility onto me, even siccing his wife on me once. It was crazy. She started calling me and even came to my job and threatened me, saying that he didn't love me and that I shouldn't keep the baby. It got pretty ugly. Needless to say, Diliza wasn't going to get his name.

I see a lot of patterns in Diliza's father that are in a lot of men, Black and White, who don't take responsibility for their families, and this really upsets me. It's not so much bringing home the money; it's taking equal part in raising the children and being able to show their feelings and not pass the buck. **I want Diliza to have a totally different idea of what a man's role in this country is.** I want him to feel that taking responsibility or showing his emotions and his love for people is a powerful, masculine quality and not something to be afraid of.

I also want to explain to him that there are dangers in being a Black male in our society, but that a lot of those dangers come from not being responsible for yourself. I have male friends who believe that their color holds them back in terms of jobs, but I think they have to get beyond that and take more responsibility for the success in their lives. Every Black person in this country has to go through an identity awakening and learn how to survive here in America, and it's a Black parent's job to show their kids how to do that. Unfortunately, many Black parents, and especially Black mothers, are too oppressed to know themselves and be centered enough to take the time to teach their children the kinds of things they need to know, and I think that's why so many of our sons find themselves in prison.

So I've talked to Diliza; I've given him positive images of Black people, and I've said, "You're a Black person who comes from Africa, and who lives in this country now. And even though you have freedoms, you still don't have enough." And that's a reality: being Black in this country can be very difficult.

But I also want to tell him about the hard things I've gone through in the hopes that he might avoid some of the things that he will be confronted with. I used to have a real party mentality. I did a lot of drugs and drank, and I didn't concentrate on anything. I wish my own father, who died of a drug overdose last year, had talked to me more about what was so difficult in his life and why he made the choices he made. Towards

124

the end, he started talking to me more about his experiences and things he was sorry for or happy for, though ultimately I think what killed him was his regrets. That and not loving himself enough. His death made me realize how much your family experience impacts you, and how important it is to teach your children about who you are and what you've learned from.

I knew when I got pregnant that I was going to have to make big changes, that I was going to have to say goodbye to Cynthia the party girl and become someone who had goals and a vision for her life and who was empowered. It was scary to think that I might have to depend on people for help because I'd be working and going to school at the same time, but I didn't necessarily think I'd need a man around. My experience with Diliza's father sort of left a bad taste in my mouth for relationships.

Men need to honor the women around them more, especially their mothers, and see them as the teachers that they are. I tell my Black brothers that they all came through a woman, and that they need to value the women in their lives if they want to find their balance. That's why I gave Diliza his middle name, Madubuike, **man gets his strength from his mother,** so he'd remember that it took a lot for me to have him as a single mother. But I also gave him the name so I'll always remember that I'm his teacher and that I have a responsibility to show him the path to becoming a man.

So much has changed for me. There have been losses, too, but I feel so much richer today than I ever did in my former life before Diliza. I still don't know exactly what my life purpose is. I need to know myself better and I need to be more mature, but Diliza brings me that sense of purpose every day. And if I'm in doubt, maybe I need to call my name out loud to myself, so that it will empower me, and call out to my spirit and to my higher purpose, whatever that may be.

And for Diliza, I hope he sees me as a friend and someone who he can come to for advice, like an elder. I hope he'll be able to say, "I have this problem, and there's only one person who can really give me some insight into it, someone who's really down for me, and that person is my mom."

125

it took a lot for me to have him

ELLEN OPPENHEIMER AND
CAROL LEFKOWITZ

ELLEN OPPENHEIMER, FORTY-THREE, AND CAROL LEFKOWITZ, THIRTY-NINE, WERE TOGETHER
FOR TWELVE YEARS BEFORE THEY HAD THEIR SON ARI, WHO IS THREE AND A HALF YEARS
OLD. ELLEN, ARI'S BIOLOGICAL MOTHER, IS A QUILTMAKER AND GLASS BLOWER.
CAROL IS A PAINTER AND A DESIGNER.

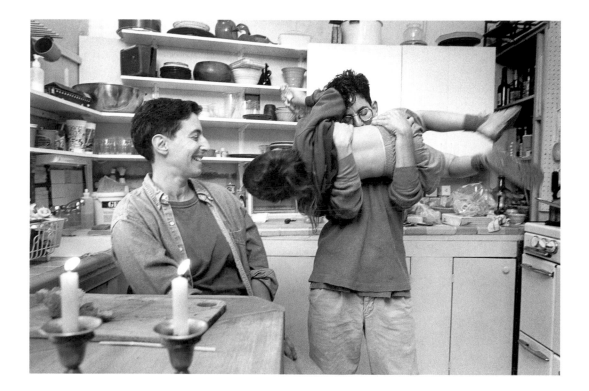

"Having children was a twelve-year conversation," begins Carol. "Almost immediately after we started dating, Ellen said she wanted to have a kid. In fact, she was very driven to have a child, and it was a difficult conversation for us because, although I liked kids, I was less sure about whether I wanted one and terrified of what that responsibility would do to myself as an artist. But after twelve years of talking, Ellen just wore me down. I don't think I actually ever said yes to a child, I think I said, 'I don't want to live my life without you, so if you have to do this, then I'll see what it will be like.' It was a tough time for us, and our relationship was definitely stretched."

"It wasn't clear to me that I was ever going to lose you," Ellen says, "but it wasn't clear to me that you were going to be a parent with me, either."

"There was this thing going on," explains Carol, "where lesbian couples were making rules like 'I'll be a 20-percent parent' or 'I'll go 60/40 with you,' but that wasn't me. I was either in or out. And if I wasn't in, then I didn't know how to have a relationship with Ellen. Anyway, **Ellen promised me that nothing would change** if we did have a child."

"That's not correct," Ellen smiles.

"Yes, it is," laughs Carol. "You said I'd get the same amount of studio time, and financially there would be no additional demands. I should've had her put it in writing!" she laughs. "It was a lie! Though I don't regret it at all. It's just that life has really changed for us, and I think that's important to say."

"Well, we do have less time now, and it does take more money," Ellen concedes. "But we're solvent, and we both still get time in our studios."

"And our relationship has changed a lot," says Carol. "We go out and we talk about Ari the whole time."

"We used to talk..." smiles Ellen, "I know we used to talk, but I cannot remember what we talked about."

128

our relationship was definitely stretched

"After Ari was born," says Carol, "my sister-in-law said, 'Now things will really change.' And I said, 'Lately all we talk about is scheduling and money,' and she said, 'Join the rest of the world.' So if we go out to dinner, it takes three-quarters of the meal to process all the organizational stuff before we look at each other and say, 'So how are ya?' "

"I'm glad that we're a family now and have Ari in our lives," says Ellen, "but I miss the attention I used to get from Carol. Sometimes she'll touch me in this sweet way and I'll think, 'God that feels good. I haven't had anything like that in a long time.' "

"I don't get much attention either," says Carol. "Ari ends up getting the physical touch from both of us."

"It's because we love him so much," explains Ellen. "The biggest lesson Ari has taught me has to do with love. A lot of people had said to me before I had him, 'You just can't imagine how much you will love your kid.' And I thought, 'Well, you're straight.' I mean, I would never say that, but I always assumed that men and women had certain boundaries that kept them from a deeper intimacy. **I thought I loved Carol about as much as anybody could love anybody—until I had Ari.** And it's true, it was just a bigger love than I could imagine. Two women are not as close as a woman and her child are. I love Ari unconditionally, and that's what makes it different."

"Yeah? I love Ari *conditionally*," smiles Carol. "When he sleeps through the night, I love him more!"

"That's true," Ellen smiles. "The first time he slept five hours straight, I woke up and said, 'Oh my God, I love him more today.' So I guess I can't say I love him uncon-ditionally, either."

"How about me?" Carol cocks her head.

"I don't know," Ellen admits. "It's just a very different experience."

"It's a different kind of closeness," explains Carol. "There's a protective love I feel toward Ari, and a way that I open up to him and feel him respond to me that is without question and without demand. **It's terrible to think that my relationship with Ellen is based on demands, but there's a different expectation I have with her that I don't have with Ari at this point.**"

129

"Ari loves us very uncritically," Ellen explains. "He doesn't care what my hair looks like in the morning, how bad my breath is, or how much money I have. I'm perfect to him no matter what I am. I will lose perfection as we both age, but **for an infant, the mother is perfect.** An adult can never love you like that. They're much more critical. Although now he says I hate you to both of us, he doesn't really hate us, he's just stressed about something."

"He says it to me more often," laughs Carol. "The egoless position I have to take with him is not always easy."

"We have such different responses," says Ellen. "When Ari rejects me and asks for Carol, I think, 'Thank God she's here, thank God he has somebody to turn to and we don't have to fight it out.' But when he asks for me, Carol feels rejected."

"That's true," Carol agrees. "I feel like he constantly asks you to save him. I think that's like the mom-dad dynamic. I'm wondering if I have a different expectation of what my relationship with Ari should be because I'm a woman, and if, for me, **being a mom is based on my gender, even though I'm really more like Dad in terms of my position.** I have a very good male friend who I talk to about this stuff, and for a while he and I were in the same place. He was very frustrated with his kid not wanting to be as close to him as his kid was with his wife, and then he decided that that was okay, and that he wouldn't push it with his family, and he backed off a little. I told Ellen about this and she changed overnight. She stopped getting in the way of stuff going on between me and Ari, and she let us figure out how to resolve our own arguments. She basically let us have the relationship we had, versus the one she wanted us to have."

"Well, at first when Carol described how her male friend had backed off," says Ellen, "I was furious because I thought, 'Of course he wants to back off, he's a busy man, he's got better things to do.' But I definitely didn't want Carol to back off. I wanted her to be involved. But then I started realizing that Carol needed to feel like I wasn't taking control all the time. Since then, everybody's dynamic in the relationship has gotten much better."

I was furious

"**I'm not a visitor here, but the dynamic is set up so that I am,**" says Carol. "In the beginning, if I had to walk through Ellen's studio with Ari to change his diaper and he saw Ellen, he would be completely on edge. It made me feel terrible. I think it had to do with the nursing thing; Ellen had her hand on him constantly. It's funny, because one of the things that I was very anxious about before Ari was born was whether Ellen would be emotionally distant from him because she had this persona to the rest of the world of being removed. I was afraid that I would have to pick up what I anticipated was going to be a lot of slack around his emotional needs. The reality is that I have to stand in line. Ellen and Ari are in sync in really profound ways. I think I was a little jealous of this in the beginning, but Ellen made a tremendous effort to include me so that I wouldn't feel separate.

"So I guess if Ari teaches me anything, it's about humility. I'm not the most important person in world anymore. He's certainly more important than I am in terms of attention and care. **I have to give more of myself, without necessarily being thanked** or being noticed, and that to me is a kind of lesson of adulthood that I don't think I would have ever learned had I not had a kid."

"For me, I'm much more available and much warmer now," says Ellen. "People I work with told me that I really chilled out after I had a kid. I used to have a nasty temper and now that's gone. It didn't seem worth the effort anymore. I had more need for companionship because motherhood can be so isolating. Why else did I soften up?"

"Well, this little thing crawled onto you and you couldn't shut down," says Carol.

"I don't know if I can explain how good it feels to be loved by your child," adds Ellen. "But picture this: Ari gets into bed with us every morning, and he looks back and forth between the two of us and he says, 'I have two mommies. I have two mommies and I love them both very much.' **That just makes our hearts burst.**"

131

MARIA XOCHITL MARTINEZ

MARIA XOCHITL MARTINEZ IS A SINGLE, FORTY-TWO-YEAR OLD MOTHER TO SIX-MONTH-OLD
PALOMA CITLALI MARTINEZ, WHOM SHE ADOPTED AT BIRTH IN MEXICO CITY. MARIA
WORKS FULL-TIME AS A HEALTH CARE ANALYST AND A COMMUNITY ARTS ACTIVIST.

The first time I held Paloma in my arms, she looked just like a little tamale. She was wrapped in swaddling blankets, and her little head was poking out, this tiny little chiquita with big cheeks and lots of black hair. I'd imagined this moment for six years and here it was, but it was nothing like I thought it would be. I'd thought maybe we'd be alone, just the two of us, mother and daughter. But instead, we were standing in the home of my friend Luzma in Mexico City, surrounded by too many people who were telling me what to do in a language I didn't speak well at all. **I had no idea my journey to adopt would end here with Paloma in my arms, though of course this was my dream.**

I'd first set out to adopt a child in 1989, and all I knew was that the baby would be a girl and that she would be Latina.

I called all the normal places like Catholic Charities, and they told me that because I was single, I should adopt internationally because a birth mother would probably choose a family over a single person. The first adoption agency charged me $700, but they weren't licensed to do domestic home studies, so when a friend suggested I call Pact in San Francisco, I did. They charged me another $650 to work with them, but then a friend put me in touch with a woman in Mexico City named Mariana Yampolsky who helped people adopt babies through the orphanages in Mexico. So I left Pact and went to yet another international adoption agency, paid them another $700 plus another $2,500 to have a home study done, while Mariana looked for a baby for me.

Each time I went to a new agency I'd start all over again, the paperwork, everything. I'd begin with all this hope because **each one would tell me that they'd find me a baby, but a million things would inevitably go wrong.** One agency lost my papers twice, one baby that I was promised died, one mother changed her mind a few days before I was supposed to go to Mexico to pick the child up. I was turned down because I was divorced, turned down because I was too old, turned down because I wasn't a property owner, because I was single. When Proposition 187, the anti-immigrant bill, was passed in California, I was turned down because I was an American. Then in 1994 the Mexican government changed hands, and nothing got done for the whole next year, so the approval-to-adopt process stopped entirely.

133

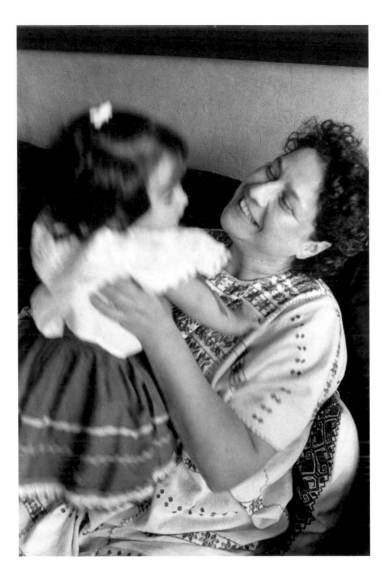

It was a wild goose chase where you hurry up and wait. I could never see past the tip of my nose, and I never knew how long it would be. They always said two more weeks, but it was two more weeks for six years.

I'd get so frustrated working with an agency because they'd never call me back after taking my money, so I'd decide that I wasn't going to work with them anymore, and then almost immediately I'd think, "Oh, God, what am I doing? What if this is the person who could take me to my baby next week?" I even let myself get involved with this con artist who told me he could get me a baby and then bilked me out of $400 and wasted seven months of my time.

I can't tell you how many times I just wept after finding out that the baby I was sup-posed to adopt was gone. For some reason, the gods were not giving me a child, and I began to feel that I must not deserve to be a mother. People would say, "Why don't you give up and move on with your life?" But I couldn't. I wanted her so bad because I had the love to give and I knew this love belonged to a child.

I kept a candle burning for her the whole six years and friends prayed for me the whole time.
The nursery had been ready for four years, and sometimes I'd just sit in there and try to imagine her face and what it would be like to hold her.

Many nights I'd sing this lullaby that my mother sang to me when I was a child.

> *Tooda lumba lumba lumba, tooda lumba lumbayae*
> *Any umbrella, any umbrella, to fix today*
> *Raise your parasol, it might be small, it might be big*
> *He will fix them all with what he calls a thingamajig*
> *Tooda lumba lumba lumba, tooda lumba lumbayae*
> *Any umbrella, any umbrella, to fix today*

I talked to my child every day, because I believe that we choose our parents, and I wanted to find out why she wasn't coming to me. **I'd picture her lying in my bed and I'd say, "Baby, why are you taking so long? Hurry and come."**

135

Every time I talked to Mariana, she was incredibly optimistic, and in 1995 she introduced me to Luzma, who took in pregnant mothers and helped them find adoptive parents. Luzma said, "Don't worry, we'll find a baby for you." I said I was single and she said, "Well, it's my experience that the mothers, no matter if they're married or single, are the ones who raise the babies anyway."

I was happy again, but I'd heard so many promises just like hers, so I stayed cautious. She said she had a woman named Blanca who was due in October and to get ready because definitely this baby would be mine. So I'm getting ready for this baby and November comes and there's no baby. December comes, no baby. So I said, "Luzma, what's going on?" She says, "I don't know. She's still pregnant." January comes and Luzma calls and says she's just accepted this two-week-old baby from a girl and can I come down Monday? I was so excited. I told everybody at work I wouldn't be there, I got plane tickets and had everything set up, and on Sunday Luzma calls to say that the girl changed her mind.

I just wept. **It was beginning to feel like a trick God was playing on me to see how much I could handle.** The next day I got another call from Luzma saying that she had taken in another young woman who was going to give birth in January and her baby was mine if I wanted it. I was so mad by this time that I said, "Don't call me unless there's a baby that I know is mine! Don't put me through this again!"

I flew to Mexico in the middle of January to meet Luzma and Eréndida, the young woman who was due in January. She was a beautiful, calm, and intelligent twenty-year-old. She already had a three-year-old son by a man whom her mother had charged with paternity because she was barely seventeen when she got pregnant, and now three years later, this same man had come back into Eréndida's life, gotten her pregnant again, and immediately left her to marry another young woman he had impregnated and whose father had threatened to kill him if he didn't marry her. Eréndida's mother had threatened to take her son away from her if she ever came home pregnant again, so she had no options.

Paloma was born on the twenty-seventh of January, and I had her in my arms on the twenty-eighth. I had envisioned this moment for so long, but there was so much activity around us that I couldn't really feel anything but terror because I had no idea how to take care of a baby. When I finally got alone with her, I sang her the little lullaby that I

I had no idea how to take care of a baby

had been singing to her all these six years, and I just wept and wept. And as Paloma watched me, her eyes got really big, and I swear she connected with me even though she was only a day old.

We went to stay with Mariana, who had never had children either, and **the two of us were totally in awe of our responsibility.** I had envisioned Paloma, but I had no idea what I was really walking into. I knew that the love that I had for her had been there for six years, but **as far as the practical aspects of mothering went, I was totally in the dark.** I called a friend who had a baby, and I was crying because Paloma was crying, and I said, "Are they okay when they turn red?" And my friend said, "No problem, she'll be just fine," even though later she told me that she was thinking to herself, "Well, how red is red?"

The first month was the hardest because Paloma was very colicky. An Indian woman asked me if I'd told Paloma where her mother went and why she wasn't here. The woman said that she was with her mother for nine months, and now Paloma doesn't understand what's happened to her. She said that I have to talk to her like she understands, because she does.

I felt awkward, but I did it. I told Paloma the whole story, and I swear Paloma looked at me as if she knew exactly what I was saying, and after that she became much less colicky, and I could settle in with her better.

Now it's been six months and the entire journey, all six years, makes sense to me, like there was a reason it took so long. But interestingly, I don't feel like the lesson of waiting, or the reason that I didn't get Paloma until now, is my lesson. I think it may have something to do with Paloma. Maybe she wasn't ready. Maybe she had other journeys to make.

All I know is that about a week after she was born, I called my mother on the phone, and **my mother said, "Has she made her way into your heart yet?" And I said, "Yes, she has," and my mother said, "Then she'll never leave."**

137

JANET IS A THIRTY-SIX-YEAR-OLD PHYSICIAN WHO HAS BEEN PRACTICING MEDICINE SINCE 1987.
SHE LIVES WITH HER HUSBAND JOHN, ALSO A PHYSICIAN,
HER SIXTEEN-YEAR-OLD STEPSON JESSE,
AND THEIR SEVENTEEN-MONTH-OLD DAUGHTER EMMA.

JANET

I've lost count, but I've probably caught between 250 and 300 babies since 1987, when
I became a doctor. But until I gave birth to my own daughter, I couldn't have described
what it was completely like to go through labor. Becoming a mother is similar; I've
treated mothers and their children for nine years, and though I've cared for them, **it was only after
I had Emma that I was able to have greater empathy for parents who call me up in the
middle of the night** because they're worried about their child's fever, or who are upset over
middle-of-the-night traumas. I'm much more understanding and less impatient with
their fears and worries.

I've probably caught between 250 and 300 babies

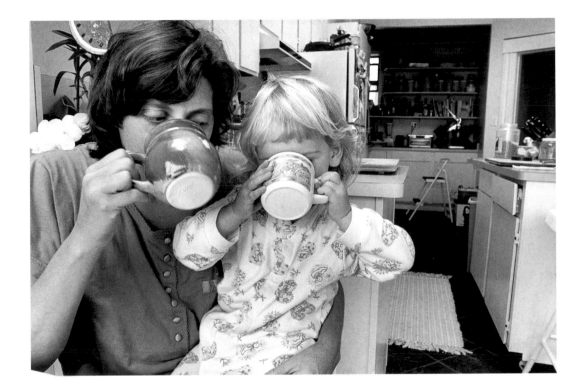

In fact, just recently Emma got sick, and it was really frightening for me. When we'd put her to bed, she was warm with early cold symptoms, but when John heard her crying at 3 A.M., he found her burning up and delirious. Her eyes were glazed and she kept moaning "aye-yie-yie-yie-yie." I felt like shouting "Call the doctor! Someone do something!" Her temperature was 104.4, so we took her clothes off, sponged her down, and gave her some Tylenol and juice with a dropper. When a kid's temperature is going up that rapidly, it's possible for them to have a febrile seizure, and I kept saying, "John, if she seizes, I think I'm going to die." I knew I could handle it, but I felt so helpless, even though I am a doctor. The thing is, there's a vulnerability that comes with being a mother, no matter what your job is.

I remember shortly after Emma was born, I had a lot of fear about the world, which seemed too scary and impure for her. It was a constant source of conflict between my husband and me. He didn't seem as conscientious as I wanted him to be. I couldn't handle the way he drove and was always shouting, **"You're too close to that car! Stop cutting in and out of the lanes!"** Another time when she was only a few weeks old, we were sitting at the kitchen table and as John passed a heavy wooden salad bowl over her head, his hands slipped slightly, and I burst into tears. These tiny things would just set me off. Nothing ever happened to her, but it was the potential for what could have that overwhelmed me.

I think it was her vulnerability and complete dependence on us that got to me. There was this deep protectiveness that I felt, and it called up an enormous responsibility in me. I know John felt that responsibility, too, but I don't think he had the same kind of emotions that I had—which were very hormonal. It reminds me of a mother kangaroo who keeps her baby in her pouch. Even though Emma was outside of me, I felt like I had this invisible pouch which I needed to protect her in.

Breast-feeding continued that bond. **Having Emma lying next to me in bed nursing was a beautiful, sweet experience; I'd lie there inhaling the delicious scent of her breath.** Seeing how much she grew and knowing that it was just my milk, only what I was providing her, made me feel so powerful and important.

140

What do you need for triplets? Well, when Aubrey, David, and Alison were little, **I probably went through thirty diapers in one day, an entire box of wipes, thirty-six bottles of formula, and dozens and dozens of burp cloths.** They went through tons of little gowns, too, so I was constantly doing laundry, because if you change a baby four times a day, that's twelve changes, and that's a lot to wash.

We have two houses, so we have six cribs, six bouncy chairs, three portable playpens, six high chairs, two changing tables, three diaper genies, two washing machines, three car seats, and a double and a single stroller. I essentially buy three times the amount of everything. My average shopping bill for a week, between the diapers, the formula, the wipes, detergent, and food is four to five hundred dollars.

I carry one big diaper bag around with me and another small one because when you're the mother of a multiple, your babies outnumber you at all times, and you can't cart around a lot of paraphernalia because you may need your hands free to hold one of them. Plus I don't have that much room in my car, not after I've put in the two strollers, the diaper bags, the extra changes of clothes, an extra package of diapers, and a box of formula and water in case of emergencies. There's just no room for packages or groceries or many more people after that.

In fact, after the babies were born, when someone from out of town would visit and we needed to pick them up at the airport, I'd call a taxi and ask them to follow me home in the cab because I didn't have room for our guest in my car. Now we have a Suburban, which is big enough for everything, and we use it a lot.

I take my kids everywhere—to the grocery store, to the Price Club, to restaurants. I often bring my nanny Celia because it's easier on everyone if we all go out together, instead of leaving her alone with the three of them. **People wonder how I manage,** but I've learned many ways to make my life easier so I don't get overwhelmed.

143

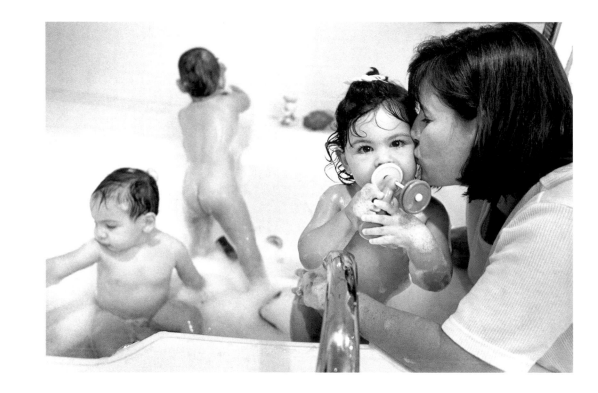

For instance, I can do half a day of errands with the kids without ever leaving the car. I go to drive-thru ATM machines, drive-thru cleaners, and the drive-thru video drop off. It's really amazing what you can do from your car. And if there's something that would normally take me out of the car, like getting a key made, then I call ahead and explain that I have triplets and ask them if they'd mind meeting me outside the shop, so I can stay in my car. I've even called up restaurants and asked them to bring the food out to the curb. Everybody is very accommodating; no one has ever refused me. **It's another world out there for me. I've discovered another world entirely.**

I've made lots of adjustments, all in an effort to simplify my life so that I can be more available to my kids. For instance, at home, I walk around with a telephone head-set on, so when the phone rings, I've got it with me. It's so much easier than looking for a ringing telephone with three children underfoot. And if I want to get together with one of my girlfriends, instead of meeting them for lunch like we used to do, I tell them to meet us at the mall or the park, and if they don't mind pushing a stroller, we can have a great time together.

I must sound so organized, but we have our share of chaos. Like today Celia and I took the kids out to lunch and to errands, and it was impossible to find three high chairs. So I left two of them in the stroller and put the third in a high chair. **I can't get hassled by these things,** not even by the crowds of people who follow us through the malls.

145

Sometimes I like the attention, but sometimes it feels like my children are on stage. We'll be shopping and somebody will see us, and they'll call somebody else over, and suddenly you have a big circle of people around you and you're saying, "Oh, my gosh!" It's hard when I'm on the go and have things to do, but it can be a very special experience, too, especially with the elderly because they take time from whatever they're doing to come over to us, and their faces light up and they'll tell us some story about their life or about how they once knew triplets and always wondered what it would be like. **I end up spending time with people who, if I only had one baby, wouldn't come up to me at all,** and I really like that because it reminds me of how very lucky I am.

See, the thing about having a multiple pregnancy is that it's very complicated, and you don't have a long-term goal of nine months because there's so much risk involved in carrying more than two children. The statistics aren't very good, and a lot of things can go wrong during the pregnancy. Sometimes women lose a baby. Sometimes one is healthy, but the other two have Down syndrome. There are cases of multiples having cerebral palsy or being stillborn. For this reason, many doctors recommend reductions, where one, two, or three of the babies will be removed so the remaining babies can thrive. You can imagine what a difficult choice for parents this could be.

During my pregnancy I'd been given a magazine called *The Triplet Connection,* and while there were many successful triplet stories inside, there were just as many tragic stories. And I had to ask myself, "Can I deal with three Down syndrome babies? Can I deal with one of my babies dying? How will my marriage handle that?" There were just too many possibilities, so, besides tossing out the magazines, my one goal was to get myself through each day and make it to the next, because the closer I got to my due date, the healthier the babies would be.

146

And we were very lucky. The babies were born at thirty-five and a half weeks, the healthiest triplet pregnancy in our hospital's history. **All three kids made it out beautifully.**

I think this focus of one day at a time, and the fear that I might lose them or that they might have serious physical problems, prepared me for being the mother of three because it slowed me down and taught me to live and appreciate each day fully.

So I don't get frazzled when they all need their diapers changed at once, or when they've all decided to throw their soup bowls down at the same time, or when one of them has discovered the cat food and has dumped it all over the kitchen floor, because I feel so grateful to have three healthy children. I don't care if they all cry at once, either. I feel lucky *because* I have three children who can all cry at once.

I hear about women who only have one child but who are frazzled, and sometimes I want to say, "You know, it's not that bad. Be thankful you have the day to get through." You have to feel fortunate if you have healthy children because there are so many people who have children with disabilities and for who getting through their day *is* a major accomplishment. A multiple isn't as challenging as that.

You do have to have a sense of humor, though. You have to be able to laugh and say, "Okay, so there's ten thousand Cheerios on the floor—what can I do?" You have to get yourself through it, instead of saying, "Oh, my gosh! Look at this mess!" If I find that I'm getting hassled, I need to sit down and take a breath and say, "Okay. I've been through far worse than this. I'll make it."

But when I see my kids laughing from the pit of their stomachs because Alison is making a face, or when my husband comes home and one of them screams "Daddy!" I get this intense rush like my blood is coursing though me all at once, and I say, "Oh, my God, I'm so happy! I love these children so much!" This is everything I wanted it to be— times three.

LAURA LEE DOBIE

LAURA LEE DOBIE IS THE MOTHER OF HANNAH, AGE THREE, AND ROB, AGE ONE. BEFORE HAVING CHILDREN, SHE WORKED FULL-TIME AS A SOCIAL WORKER AND CONTINUES HER PRACTICE ONE DAY A WEEK. SHE LIVES IN THE SOUTH WITH HER HUSBAND BRUCE, A NEWSPAPER EDITOR. SHE IS THIRTY-SEVEN.

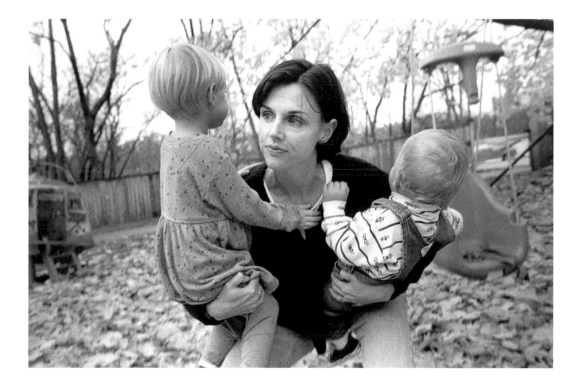

and we sat there, and sat there and sat there

Being a mom can be such a mind game sometimes. The other day Hannah and I were in the car on our way into town. I usually allow her to sit in the back of the station wagon as we drive through the alley behind our house, and then when we get to the main street she gets into her car seat again. So we hit the street, but Hannah says she's not getting in the seat. "Well, then we can't go anywhere," I said. But she wouldn't get in, so I shook my head and said, "Then we'll sit here."

And we sat there. And sat there and sat there. After about five minutes I'm getting really angry and I'm thinking, "Okay, we're sitting in the car, we're not going anywhere. What do I do? What's the plan here?" So I decide to get out of the car and sit down on the curb—sort of a little protest of my own. And Hannah says, "Mom! I want to get out, too!" "Nope," I said, "you've got to get in your car seat. The car can't go until you get in that seat." But she wouldn't get in, so I sat there on the curb, in the middle of the day, my hands folded over my knees, listening to my kid shouting, "I want to get out of the car." And I'm thinking, "This is the dumbest thing I've ever done in my life, but I don't know what else to do."

Surrender—that's a big part of motherhood. You have to get in the mind-set of "It's not important if I get the laundry done today or if I get to the grocery store."

You can't want control. Control is out of the question, because with kids there's no way to anticipate what your day is really going to be like. You can think things are going to happen a certain way, but then five tantrums later it's happening a different way, and you pretty much have to go with it. Now I'm used to it, but it was a shock in the beginning, all that letting go of the world that I thought was mine.

I think any woman who's had a sense of independence would feel this way when she becomes a mother. As women, we've been educated, pushed along, and told that we could accomplish anything we wanted to and become anything we set our hearts on. But after you have a child, you hit a brick wall and you realize that if you really want it all, **if you want your family and your brilliant career, then somebody's going to pay, and that somebody may be you,** or your marriage, or your kids. And you have to ask yourself, "Do I really want it all, if it means that someone is going to suffer because of it?"

I couldn't do it. Working full-time just brought on too much chaos for me. I was getting my children up in the morning, getting them dressed, fed, rushing them out the door to day care, rushing to my job, working, coming home from work, trying to see my kids, talk to my husband, play with the kids, get them fed and to bed. I knew

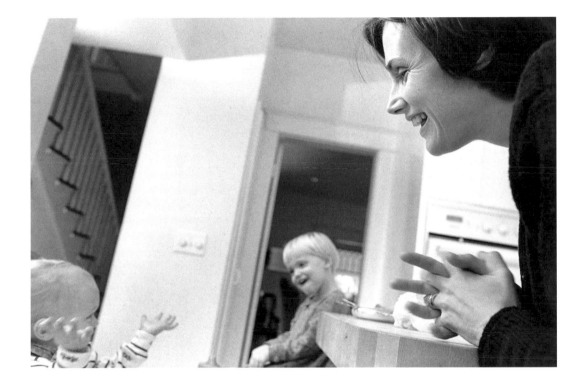

that it was just a matter of time before something was going to give, and I didn't want my children to live in that kind of chaos. God bless the mothers who have to work and who don't have a choice about it, because it's really hard to do it all.

At the time I'd been working full-time as a social worker, and while I did make a sacrifice by going from five days to two days a week and then down to one day, I don't feel like I gave up a huge career, either. If motherhood made me give up anything, it was a certain sense of freedom to go and come as I pleased and make spontaneous choices about what I felt like doing in the moment.

Now my decisions are made with my children and my husband in mind, and while that's wonderful, it's very different.

At the same time, motherhood has turned out to be much more rewarding than my job was, though not rewarding in the way our society views rewards. These days I feel rewarded if I can get Hannah into her car seat and get her potty-trained. I felt a weird kind of reward when I went to buy them shoes yesterday, because it meant that they were growing. I felt the same satisfaction when I took Hannah to play school for the first time and she cried only a little bit, but the next time didn't cry at all. Before that she never liked to be without me, so to see her hold her head up high and walk into that place by herself was my accomplishment, too; she's learning to be an independent person, and that makes me feel good.

The truth is that my life is about my family these days, and my rewards come in relationship to them. I might have rejected that notion five years ago, when I was career-bound and knew myself as a professional woman. I'd been raised in the '70s and '80s, after the women's movement had been rolling, and I believed that I would carve my own path and not live through my husband or my children. But the thing is, this time with my children is so short-lived, and it's really important for me to be here at home for them, which also means that I've had to expand my notion of where my rewards are found.

And maybe because my generation of women was taught to be independent, I still carry the essence of that with me. I know myself enough and have enough self-esteem to not live through Bruce's accomplishments, either. He's the editor of a newspaper in town, a paper which he and his partner just recently purchased. That was a big deal this summer, and everybody was saying, "Oh, you must be so excited!" And while I was excited, I didn't feel a personal sense of accomplishment because it wasn't my deal, it was my husband's deal. In the '50s and '60s, that would have been "our deal." So I have to sit with myself on this and realize that while my job as a mother may not seem like such an outwardly successful role, for me that's okay because

I really believe what I'm doing is a good thing.

I've had to **expand** my notion

Then, once the twins were born, things changed even more because I was alone with all three girls every day while Lloyd was at work. It got very chaotic. I breast-fed the twins every two hours and could have been totally focused on their needs, except that Emma wanted me to read to her and play with her. But **because I had two on the boob or two crying for me or needing their diapers changed, I ended up shutting her down a lot and pushing her away.** I'd tell her to stop crying rather than let her cry, and I felt awful because I'd always encouraged her to express herself, and now I couldn't handle that expression because I was too overwhelmed.

We went through some really hard times, and I lost it a lot because the twins needed so much and Emma was pushing and pulling at me all the time. Once I was so crazed that I left them all in the room screaming and went into the other room and hit my head against the wall and cried, "I don't want to do this anymore! Why did I choose this?" I was always able to come back and regroup, but I had to dig deep and remember that the girls were gifts from God and the Goddess and that I was their guide, so I really needed to pull myself together. A couple of times I ended up spanking Emma, too, which was something that I never thought I'd do because I didn't believe in it. But I just lost it.

I guess I thought she would automatically grow up and be able to take care of herself after the twins were born, but she was only three years old and still very attached to Mama. I'd ask her to dress herself in the mornings when I was changing the twins, but it didn't happen, and I'd get frustrated because I'd have asked her twenty times and then it occurred to me, "You know, Rebecca, she can't dress herself yet."

That's why the book I made for her is so special for us, because it brings me back to the way we felt about each other when it was just us, before things got so crazy around here. Part of what hurts me now is that because of the separation that Emma and I have had to go through, I forget what it feels like to hold her in my arms and feed her. I forget what it's like *not* to have a three year old saying no and yelling back at me. I forget what it's like to have that beautiful, wonderful, Emma and Mama dance together, play together, and have a wonderful time together relationship. But when we read the book, I get a glimpse of what that felt like.

the way we felt about each other when it was just us

The thing that really saved us and made me sane again was that Lloyd and I moved back to the town I grew up in, to be closer to my parents and to get some support. Now we live two miles away from my mom and dad, instead of in another state, and we see them every day and have dinner with them at least three nights a week. They take Emma a lot and give Lloyd and me one night out a week for ourselves. It's like one big household, one big extended family with them. They're the only people in this world who have experienced all three kids at once by themselves, so they know what it's like.

Their willingness to take all three girls amazes me, and I can't believe I did it without them.

But even more than the physical help that they've given me, they've helped to fill in the gaps that Lloyd and I couldn't fill because we were so overwhelmed, and they've filled those gaps in with love. So because of their nurturing, and because I don't have all of the responsibilities of mothering on my shoulders like I did before, I've been able to become the mother I've always wanted to be. I have more energy and more time to sit back and think more about me and what gifts I have to offer and how I want to grow.

Before I had the twins, **I thought life was more about the light, and I never realized that darkness is a part of life, too, and a part of myself that I needed to embrace.** Emma brought out the darkest parts of me this past year. She's shown me that I have a wicked temper, and not a lot of patience, and that sometimes I get angry and yell and lose it. I never knew these things about myself. I was more of a Pollyanna before, good at everything I did and always striving for perfection. But this past year I don't feel that I was such a good mom all the time—but that's okay. It was a hard first year with three girls, but now that I've gotten some help, I can stand back a little and embrace the parts of myself that did emerge, and I come away feeling like a much more complete person. **Today I don't feel like I have to get an A+ at mamahood, and it's a huge relief to let that go and just be who I am.**

good at everything I did

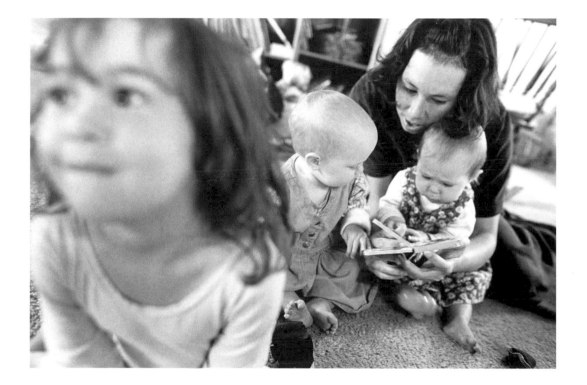

WINN ELLIS

PSYCHOLOGY GRADUATE STUDENT WINN ELLIS IS THIRTY-SIX YEARS OLD. SHE AND HER HUSBAND DAVID ADOPTED TWO-DAY-OLD TESS AFTER TRYING UNSUCCESSFULLY TO BECOME PREGNANT. TESS IS NOW ONE YEAR OLD.

I always envisioned myself as a mother, I just didn't have any idea that *becoming* a mother was going to be so trying. Six months went by, then eight months; the next thing we knew, David and I were sitting in front of an infertility specialist.

I kept thinking we weren't doing it right. So I talked to a few friends who had gotten pregnant, and we made sure we had the ovulation kit and the temperature chart. But when another month went by, denial reared its ugly head and I was having thoughts like "Maybe it's not a good month," or "David was traveling so much of the time." But the whole dawning of "My God, this is really happening to me, I'm not going to be able to get pregnant" felt like somebody else's life. **I'm supposed to be able to have children**—it's a right that we're all entitled to. But soon David and I were asking ourselves questions like "*Will* we become parents? *How* will we become parents?"

After a year of trying, we decided to pursue infertility treatments. It was an extremely traumatic experience for us, emotionally and physically. Pursuing fertility became a kind of second job for me because it was an elaborate process of scheduling challenges, daily injections, blood draws, and painful medical procedures, which for me included three surgeries and two in vitro fertilization cycles.

Finding support was the key to our survival. As we began to meet other couples who were going through the same thing, we didn't feel so different from everyone else we knew. Spending time with pregnant friends and going to baby showers had become increasingly difficult for me to deal with. **It was the "fertile world," and it was a place I didn't want to be, so I just turned off.** It seemed like everybody else was getting pregnant or on their second or third child, and people who we started trying to get pregnant with already had a baby. I ended up not going to the baby showers after a while, and it was very hard on friends; they didn't know what to do with me. I was happy for them, but every time we got together I had to steel myself against my own anger and pain. It was a very emotional period for me.

161

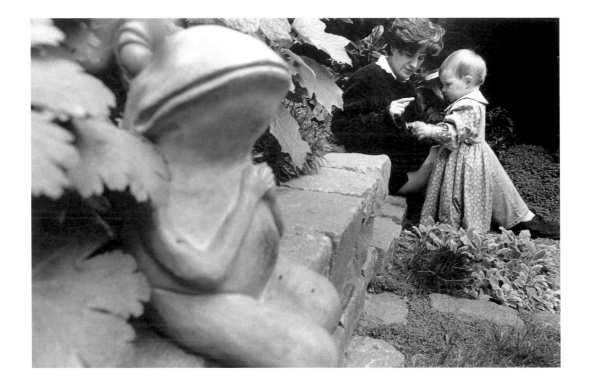

Anyway, the in vitro procedures didn't work, the surgeries didn't work, and our fertility problem was never explained. We both checked out fine medically. **It wasn't David's problem or my problem—it became *our* problem, and that was important to remember as a couple.** I had to say, "No, it's not me, it's us, we can't do this for each other at this time." You have to resolve it because you can get caught in this downward spiral; some couples go through five or six years or ten IVF cycles, and marriages suffer, relationships with friends suffer. We were determined not to do that. We had to move on.

 We started thinking about adoption and began couple's counseling to deal with the issues we needed to face. There were big concerns for us, and a huge grieving process we needed to go through. If you don't properly do that then it's unfair to the child you bring into your life, because you're always trying to impose your own expectations onto them.

 The hardest part is not creating this biological child between the two of you, not passing on even the most basic of traits, like David's warm blue eyes or my brown hair. When you adopt, you need to be able to get beyond certain things in your own biology and remember to validate all babies as individuals from the very beginning. If you're always assuming that she looks like you, then I think you're in for trouble because you just won't find it. **Don't look for Aunt Sophie's personality, or Uncle Hester's quirky grin; babies are their own little selves.** That's how we all should feel, biological and adoptive parents alike, but adoptive parents come into it like that. What it really came down to in the end was that we just wanted a family. Biology didn't matter after a while.

 And then Tess came to us. She came to us in twenty minutes. We'd been on vacation, and the day we got home the social worker called to tell us about Tess, who had been born two days earlier. I asked what they knew about her, and she said that Tess was a healthy baby girl and that the birth mom's adoption plan had fallen through. My heart was racing and I told her that I needed to talk to David before we made a decision, but she called us back twenty minutes later and said she needed our answer immediately. David and I looked at each other and realized that it felt right, that this little girl would be ours.

163

So we dropped everything and went over to the hospital to meet the birth mother and Tess. The nurses showed us how to feed her, how to take care of the umbilical cord, and sent us on our way. It was one of the most terrifying and exhilarating moments in my life. I had always imagined that when I saw the baby who was going to be ours, that I would just burst into tears of happiness. But when I saw Tess, I was so focused on how I was going to take care of her that the whole image of that important first moment was just shattered, and I went into auto-pilot. I was determined to make it work, though none of the emotion sank in until days later.

So at two o'clock that day we got the phone call, and by 5:30 we were driving home with our daughter. We didn't have a thing—no diapers, no blankets, no car seat— because the thing about infertility is that the last thing you do is set up a shrine and get the room ready. You just don't want to jinx your chances. You don't allow yourself to read books on newborns or gaze at baby clothes. You don't even allow your-self to get the basics ready. But **all of a sudden this door which had been closed to us just slammed open.**

I remember feeling guilty during the first week because there I was wanting this baby for two years, but no one ever told me how hard having a baby was going to be. People skip over that part. I think it was sleep deprivation combined with the fact that our relationship was thrown into a complete tizzy of responsibilities and exhaustion. We were bumping into each other, not really sure how to handle baths or long cries or spit ups. I mean, **suddenly you have this little person in your life who needs you almost every moment of the day.** We'd had no prep classes and found ourselves going on sheer instinct and common sense.

Despite our overall joy, those first weeks were a really lonely time for me. Even if you have your husband and your mother and friends, it's still exhausting because you're dealing with new emotions that you don't know how to express or process, and you're feeling inadequate and asking yourself, "Is this what I really wanted? And why aren't I in this blissed-out state that everybody talks about?"

It wasn't that I loved her any less, it was just that I was overwhelmed.

164

none of the emotion sank in until days later

The other thing I was feeling was that I should've felt more bonded with Tess, that it's supposed to be this big coming together, and although I loved her and was thrilled that she was in my life, I didn't bond with her instantly. It took me a good month to feel like I wasn't taking care of someone else's baby. Later I understood that this was a natural feeling, even for biological mothers, who admitted that they felt the same way.

By the third month it was totally different. It took a little while, but I think it was the combination of Tess coming out of that unresponsive infant stage and me becoming more comfortable with my role as a mother and primary caregiver.

After hiding out during the infertility and not wanting to prepare at all for motherhood, I now get such a kick out of doing even the most mundane baby errands. I find myself lingering in the baby aisle in Walgreens—comparison shopping for diapers and formula and checking out the latest tippy cup technology. I know that sounds ridiculous, but what may seem like tedious chores for some new mothers were like little victories for me. A year later, I still like shopping for Tess, especially when she's with me and I can show her off. I'm proud of that and love that we're a team.

Little things move me, like when I hear her name at the doctor's office—Elizabeth—that's my daughter! There's a sense of finally being there, of finally indulging myself in those emotions.

I've also gone to a couple of baby showers since we've had Tess. Now I can appreciate the joy of the baby and share stories with other mothers. As long as it's not labor, delivery, and breast-feeding stories, I'm right there with them. It's a huge relief to be back among the normal cycles of life.

Motherhood has allowed an entirely new part of myself to emerge. I'm more compassionate now. I see children differently. News stories never really affected me like they do now. Tess has taught me that—to be more aware of a child's plight, but also more importantly, to be aware of their joy. **It's like I've grown a new piece of my heart.**

After this story was written, Winn and David adopted Tess's biological sister Claire, who is now two months old.

I know that sounds ridiculous

THEA BECKER

THEA BECKER IS THIRTY-ONE; HER SON OREN IS TWO. THEY LIVE WITH THEA'S MOTHER AND STEPFATHER
IN THE HOUSE THEA GREW UP IN. A SINGLE MOTHER, THEA IS AN ARTIST AND A CLASSICALLY
TRAINED PIANIST WHO IS PURSUING A CAREER AS A COMPUTER ARTIST.

It seems like I always manage to get myself into the thick of things, and being a single
mom is quite the thick of things, I think. I didn't plan it this way. Believe me, I
had all the dreams of a secure, complete family unit, because I'd come out of a
divorced family and I was dead-set against having a child in a broken relationship.
But circumstances worked such that I'm without a partner.

I had Oren in Amsterdam. I'd gone there to fulfill a childhood dream of living in
Europe, but I'd also gone because I wanted to discover the artistic part of myself, and I
needed to be far away from my family to do that. It's just that I've depended on them
so much for financial support, and leaving America was an adventure and creation of
my own. **If I've lacked anything, it's been an inner confidence and the sense that I could take
care of myself.** I was raised to believe that somehow I wouldn't have to be fully responsible
for myself, which was how I saw my mother. I know she has the capacity to fend for

I needed to be far away from my family

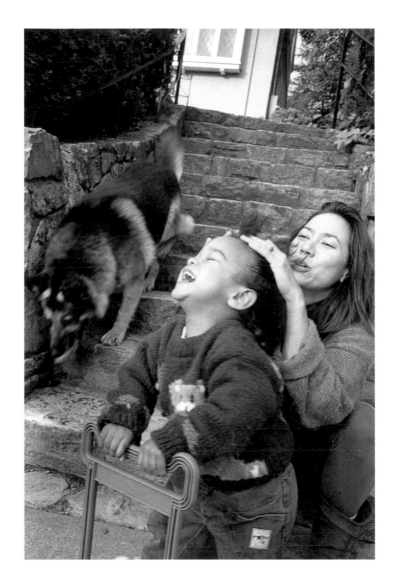

herself, but I don't think she's had to exercise that to the fullest extent, and therefore I'm not sure she has that inner confidence. I certainly didn't, but I'm developing that now through my situation.

I met my boyfriend Nathan early on in Amsterdam, and we began living together. The hard part was that he was established, with lots to do and many friends, and I didn't have a specific plan of action that I was pursuing, and it felt like I was waiting around for him a lot of the time, instead of getting on with my own life. After three years we broke up, because I needed to get out on my own and make my life happen. So I moved out, which was really distressing, although he was still coming over and we remained intimate.

Freddy was a friend, a Black musician whom I'd known for a few years, and one night during this breakup with Nathan, we went out. **The evening started off nicely, we were laughing and drinking, but before I knew it, I was drunk and somehow we were in bed together.** I don't even remember how we got there. I was feeling low and unloved, and it was a really typical thing of thinking that sex would give me a feeling of honest caring. Instead it was empty and it wasn't what I wanted, so I managed to stop it before it got too out of control.

A month later I found out that I was pregnant. I had no question that the baby was Nathan's, so we got back together because we wanted to have and raise this child together. **It was only when I saw the top of Oren's head coming out of me during the birth, and when I saw how dark he was, that I had a clue that there was something strange going on.** And then I thought, "Oh, my God. No. This couldn't be." I'd put the whole Freddy thing out of my mind because it was one of those situations that I would've rather forgotten about. Besides, I didn't think we'd gone far enough to make a baby.

As the weeks went on and Oren grew, it became clear that we had a problem. I knew I couldn't go through life keeping this secret, so one night I got a little drunk, and the whole story of Freddy came spilling out.

Nathan didn't move out right away. He was very understanding, but he had too much pain over the fact that Oren wasn't his, so he began acting more and more coldly towards Oren, and that was extremely painful for me. I had also begun to withdraw from Oren to some extent because I was struggling with the fact that he wasn't

168

Nathan's. But at the same time, **I was experiencing a kind of density of love with Oren, a vibrating kind of love that I've rarely felt in my life and that I couldn't deny.** As much as I was in pain over Nathan and what was happening to us, I felt an incredibly intense connection to this child. I saw Oren as a beautiful soul who had come through me, and I realized that I needed to be in a situation where I could fully honor the gift of who he was, even if that meant leaving Nathan. Of course, this was the most challenging step for me because it meant facing all the issues that I hadn't dealt with in my life, like having to be fully responsible for myself and, now, for my child.

Now Oren and I are back in the states, living with my mother. Nathan is still in Amsterdam, and I'm not in touch with Freddy anymore.

By coming home, I feel like I've begun the process of starting over and creating a new life for myself. I knew I needed help from my family to make that happen, and even though some people might see coming home as taking a step backwards since I had left to seek out my independence, I don't see things that way. Life isn't that linear. For me, it's all a process of inner growth, no matter what form it takes. Sometimes I do feel stuck, and I wonder what I'm still doing at my mother's house, but mostly I feel grateful that she and my father believe in me enough to support us.

And when I look at Oren, I see this incredible, blossoming being. I've absolutely let go of the fact that he isn't Nathan's son. That's not important anymore because who his genetic father is, is not what life is about, and it doesn't have anything to do with who he is going to become. What I know is that my son teaches me a lot about how to love; it emanates from his being. He is the most joyful, delightful spirit. And **when I'm around him, I'm more in touch with the love in me, which gives me the strength to face the challenges of being a mom without a partner.**

This isn't how I planned it, but motherhood has been an opportunity to grow in more ways than I could have imagined. You have ideas about the way your life should go, but then things happen that take you in entirely new directions, and while that may seem hard and scary at the time because you have to give up certain pictures, if you take what's in front of you and learn from it, you will grow.

169

ZILLAH

ZILLAH IS A THIRTY-FOUR-YEAR-OLD FOOD WRITER WHO LIVES WITH HER TWO-YEAR-OLD DAUGHTER
SOPHIA AND HER HUSBAND JIM, A COMPUTER CONSULTANT.

Something I do, which is a total mistake, is that I curse other drivers when I'm driving. Both my husband and I do. We're generally very nice people, but when we're driving and people cut us off, we turn very nasty. Well, Sophia hears this and repeats the things we shout. It's actually pretty funny to hear a two year old shout things like "He's an idiot, Mom," though we ultimately don't feel good about it. But lately, instead of mimicking us, she'll say, "Mommy, that person is not a bastard, she's a nice person. She's a good person." And I'm thinking, Why is she defending a person she doesn't know?

Where does this need for fairness

and balance come from? But at the same time, I appreciate so much wisdom coming from such a small person. I think it's because the other parts of her life are in place that she recognizes the good in the world and wants to remind us of it.

I curse other drivers when I'm driving

This is part of the magic of having a child. **She doesn't exactly take the burden of my adult concerns away, but she makes me realize how trivial most of my problems are.** Like lately she's begun to say "I love you" to us, and of course we totally melt. Sometimes I'm not sure what she's getting at because she'll say it twenty times in a row, but sometimes it feels so genuine, like it's this burst of emotion. Like the other day, I was looking for messages on my e-mail and I said, "oh, no" because I didn't get any, and she said, "Mommy, what's wrong?" I said, "I didn't get any messages," and she said, "Mommy, I want to hug you, I want to make you feel better." It was just e-mail, but here she was hugging me and making me feel great.

It's these bursts of emotion that inspire my husband and me to say "I love you" more to each other, because Sophia makes herself so vulnerable when she puts herself out like that; she makes me feel that I can let my guard down, too.

I think what it comes down to is that Sophia feels very good about who she is, and this impresses me because I didn't necessarily feel this way myself. I'd been a very meek child and young adult, a "pleaser," really, and not sure of who I was. As a mother, I was concerned that I wouldn't be able to show Sophia how to feel confident about herself, and there have been times when my obsession with trying to make sure that she knew how to take care of herself has gone a little overboard.

Like lately, I've been obsessed with this segment in a book called *Madeline and the Gypsies,* where Pepito and Madeline get stuck on the Ferris wheel in the rain and Pepito climbs down to get help for her. And that angers me because what is it about Pepito that makes him able to climb down from the Ferris wheel alone, and why does Madeline need his help to do the same thing? So I told Sophia—not that she cared— I told her that she could climb down just like Pepito did.

171

Shortly after we read the story, we went to the park where she was learning how to climb this steep slide that she hadn't been able to do before. She'd made two successful climbs and wanted to do it again, so I said, "You can do it. Just like Pepito climbed down the Ferris wheel, you can do it, too." But this time she slipped and bit her tongue and burst into tears. So I picked her up and felt guilty because I was being pushy and too obsessed with this story, and a minute later she was screaming through her tears, "I'm fine, I'm fine! I want to go back up the slide!" She knew that she was going to experience the pain but that it would be over soon, and she wanted to get back to what she was doing. She was even crying as she climbed up the slide.

As I watched her, I was amazed at how self-possessed she was, how she could anticipate that every bump and bruise is not the end of the world. I would have been defeated by that as a child and I certainly wouldn't have gone back on the slide. When I see her strength and courage, it makes me feel more capable as well.

In fact, I think **negotiating the world as Sophia's champion has given me a stronger internal voice that has allowed me to expose myself and take more chances.** I'm much more comfortable with who I am and less likely to apologize and make excuses for myself. Once, when Sophia was younger, we were at a cafe and this woman sitting next to us asked how old she was and I said, "She's one year old," and she said, "One! She's so small!" And I said, "Thank you," in a really sarcastic tone. The woman was crushed, but I was fine with it. I just wasn't in the mood for a stranger to make a comment about my daughter's size. I thought it was rude.

Before I was a mother, I might have let a comment like that slide, even if I didn't think it was appropriate or I was hurt by it, because I wouldn't have wanted to offend the woman. **But I've come to a place where you have to take me for who I am.**

Maybe that's a factor of growing older, but maybe it's a factor of becoming Sophia's mom.

172

I'm fine, I'm fine! I want to go back up the slide!

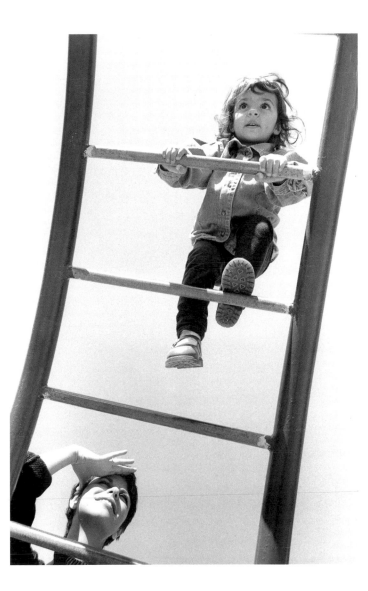

THE END